IMAGES
of America

HAGERSTOWN

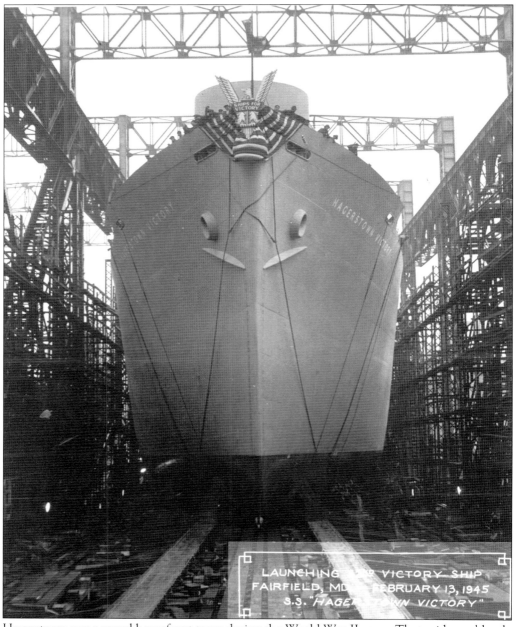

LAUNCHING __ VICTORY SHIP
FAIRFIELD, MD __ FEBRUARY 13, 1945
S.S. "HAGERSTOWN VICTORY"

Hagerstown was a proud homefront town during the World War II years. That pride could only have been enhanced when the 32nd Victory ship, the S.S. *Hagerstown Victory*, was launched at Fairfield, Maryland on February 13, 1945. (Courtesy Washington County Historical Society.)

IMAGES
of America

HAGERSTOWN

Mary H. Rubin

ARCADIA

First published 2001
Reprinted 2002, 2003

Published by Arcadia Publishing
Charleston SC, Chicago IL, Portsmouth NH, San Francisco CA

Printed in the United States of America

Library of Congress Catalog Card Number: 2001089679

For all general information contact Arcadia Publishing at
Telephone 843-853-2070
Fax 843-853-0044
E-mail sales@arcadiapublishing.com
For customer service and orders:
Toll-Free 1-888-313-2665

Visit us on the Internet at www.arcadiapublishing.com

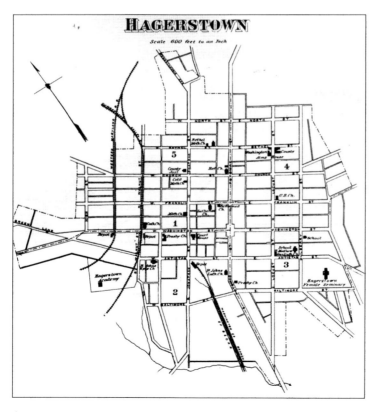

This 1859 map shows Hagerstown as it appeared at that time. Numerous churches and other important buildings are noted on the map as well as the rail lines for the three railroads that served Hagerstown in 1859—the Western Maryland, Cumberland Valley, and the Baltimore & Ohio (B&O). (Courtesy *Maryland Cracker Barrel.*)

CONTENTS

ACKNOWLEDGMENTS

The author wishes to gratefully acknowledge the help provided by Mindy Marsden, executive director of the Washington County Historical Society, and John Frye from the Western Maryland Room of the Washington County Free Library. They generously opened their collections to me as well as freely shared all manner of information. This project would not have been possible without their assistance. I also wish to thank Frank Woodring for so generously sharing the *Maryland Cracker Barrel* collection of photos and the historical information contained in the magazine that proved to be invaluable. I would also like to thank Kay Rubin for assistance in gathering many pieces of information and Clint and Shirley Rowland for their "what Hagerstown used to be like" stories.

INTRODUCTION

For over two centuries, since its founding in 1762, Hagerstown has been a central player in the history of our country and is literally at the crossroads of history and commerce. The town lies just north of the Potomac River in the heart of the Cumberland Valley. The Conococheague and Antietam Creeks cut this valley, known locally as the Great Hagerstown Valley. Originating in Pennsylvania, these two streams also cut the northern part of the Great Valley in Pennsylvania known as the Cumberland or Lehigh Valley. The Great Valley continues south across the Potomac River into Virginia where, known as the Shenandoah Valley, it was formed by the Shenandoah River. This scenic valley between the Blue Ridge and Allegheny Mountains provides a north-south route that migration, war, and commerce have followed through the years. Additionally, the great Potomac River provides a natural east-west passage that America used as the gateway to settling the West.

Residents encountered Native Americans in the early years of settlement as the abundant wildlife in the area made the valley a popular hunting ground. Some of the area's place names today come from native words such as "Antietam," which meant swift, flowing water. For those early adventurers who pushed on from the East Coast to penetrate into this fertile valley and carve out a new life, Native Americans were a constant threat. With the unknown wilderness to the west and the Blue Ridge Mountains to the east, there was little hope of timely help in case of attack. This need to rely upon themselves made the early settlers of the area an independent race.

After the Revolutionary War, Washington County (of which Hagerstown is the county seat) was created on September 6, 1776. Originally part of Frederick County, the new county was named for George Washington who would later become the commander-in-chief of the Continental Army. General Washington had spent time in the area working on schemes to improve navigation on the nearby Potomac River, hoping to link it to the Ohio River with a series of locks and dams. One of Hagerstown's main thoroughfares through downtown, Washington Street, would take its name from the country's first president.

As the new, young country began to grow, so too did Hagerstown. Pioneers moving further westward traveled the National Pike through Washington County, and Hagerstown became an important stopping point. Settlers heading out to the west took Hagerstown Almanacs with them, as well as many other products manufactured in Washington County to be sold at western outposts. Thousands upon thousands traveled the National Pike route, once the busiest road in the country, from Baltimore to the Pike's end in Illinois. Tollhouses collected

fees for the use of the road, and inns and taverns sprung up all along the way to accommodate weary travelers.

The coming of the Chesapeake & Ohio (C&O) Canal and, later, the railroads, brought increased prosperity to the growing town, which was once the third largest city in Maryland. As western farmlands began to develop, trade with the East Coast increased. The C&O Canal, begun in the late 1820s, was designed to meet the need for a faster method of transporting goods. So named because it was intended to begin at the Chesapeake Bay and continue on to Ohio, the canal followed the Potomac River. In 1867, the Baltimore and Ohio (B&O) Railroad opened a line to Hagerstown with the intention of competing with the canal. The railroads soon proved to be far more efficient than the canal boats, and rail traffic increased dramatically.

With its critical location on the North/South border, Hagerstown was heavily involved in the Civil War. The town served as a supply center and staging area throughout the war years and was occupied several times by Confederate troops. One of the most notable events was the Ransom of Hagerstown during 1864. On July 6, 1864, General McCausland demanded the sum of $20,000 as well as clothing supplies for his troops from Hagerstown or the town would be laid to waste by fire. Working together, the Hagerstown City Council and three local banks were instrumental in hastily gathering the funds to meet the demand and save the town.

Hagerstown continued to grow and thrive through the remainder of the 19th century and on into the 20th. Today, as the town moves through its third century and on into the new millennium, we would be well served to slow down from today's hectic pace for a few moments and take a look back on where our town has been. The photographic retrospective presented in these chapters documents the places and events that helped shape this historic town. A better understanding of the past that shaped Hagerstown will allow residents to look to the future with pride and confidence.

One

HISTORIC BUILDINGS, HOMES, AND VIEWS

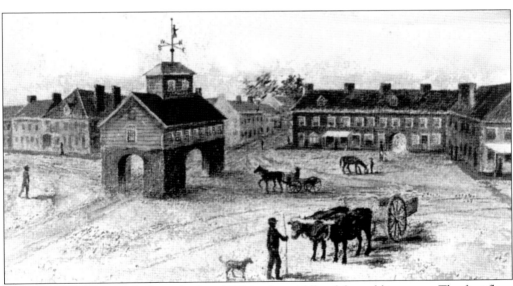

Hagerstown's first town hall was built *c.* 1769 in the middle of the public square. The first floor was an open-air market, and farmers drove their wagons through the open archways. Note the weathervane, Little Heiskell, which can be seen on top of the building. Made in the shape of a Hessian soldier in 1769 for the first city hall by a German tinsmith, Little Heiskell is the symbol of Hagerstown. A sharpshooter used him for target practice during the Civil War and shot him through the heart. He remained on top of city hall until the third and current building was constructed. He can now be seen in the Hager Museum in City Park. (Courtesy Washington County Historical Society.)

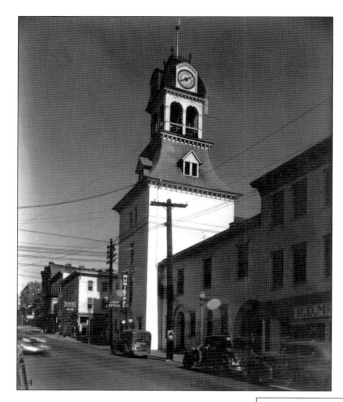

After only 33 years, Hagerstown's first city hall was deemed too small as well as awkward to have in the middle of the town's two main roads. Construction on the second building, pictured here, was begun on June 24, 1822 and it was located one block north of the square on the corner of Franklin and North Potomac Streets. The clock in the cupola was the work of local clockmaker Arthur Johnson. (Courtesy Washington County Historical Society.)

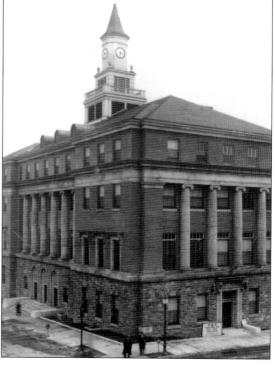

Hagerstown received grants from the Public Works Administration in 1938 to plan and construct a new city hall. This photo, c. 1939, shows the new building with the PWA sign out front. A replica of the original Little Heiskell weathervane flies above the clock in cupola. This third city hall is still in use today. (Courtesy Washington County Historical Society.)

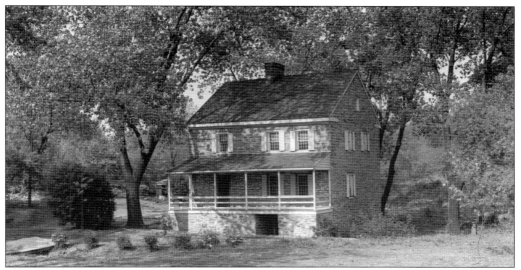

The Hager House was the home of Jonathan Hager, the founder of Hagerstown and one of the earliest settlers in Washington County. Built in 1739–1740, the house was styled in the German tradition and was built as a fort home and fur trading post. The walls are 22 inches thick and the home, originally one-and-a-half stories high, spans two springs, which ensured a fresh water supply in the event of an Indian attack. Hager used the basement as a blacksmith shop and the upper floors as living quarters. Ultimately three-and-a-half stories high, the home appears here after its restoration in 1953. (Courtesy Washington County Historical Society.)

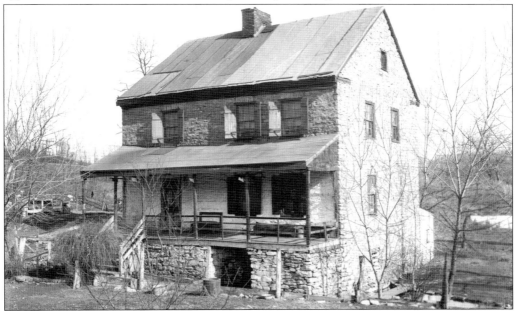

This photograph shows the Hager House in 1948 prior to restoration. Known as "Hager's Fancy," the home was sold by Hager to the Rohrer family in 1745. The parcel remained in the Rohrer family until 1944 when the Washington County Historical Society acquired the property. Located in City Park, the restored home today is open to the public along with the adjacent Hager Museum. (Courtesy Washington County Historical Society.)

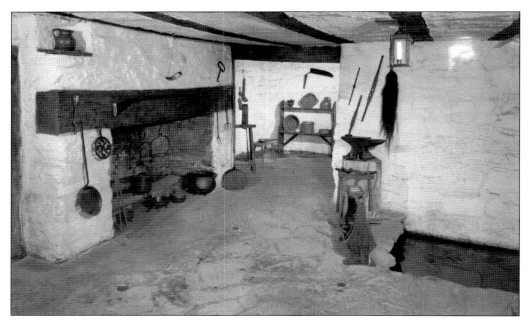

In this c. 1964 photograph of the interior of the spring room at the Hager House, water can be seen flowing under the floor on the right. While certainly providing a cool place in the summer, the house had been located over the springs for more important reasons. During the 1740s, Hagerstown was still considered to be in the wilderness of Western Maryland. To this end, building over the springs guaranteed a protected water supply—any attempt by Native Americans or other enemies to poison the water would be washed away as the fresh water continually bubbled up. (Courtesy Washington County Historical Society.)

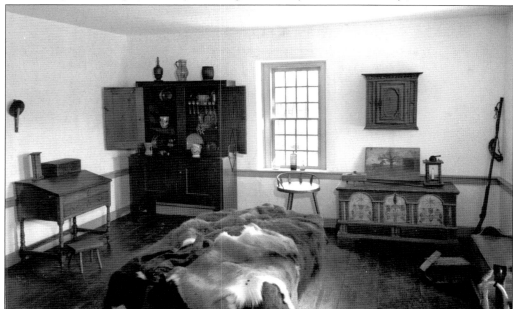

Here is an interior view of the Hager House. Note the depth of the ledge on the window. (Courtesy Washington County Historical Society.)

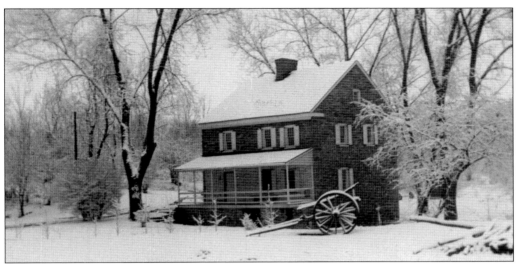

A winter snow provides the backdrop for this scenic photograph of the Hager House taken on February 6, 1957. (Courtesy Western Maryland Room, Washington County Free Library.)

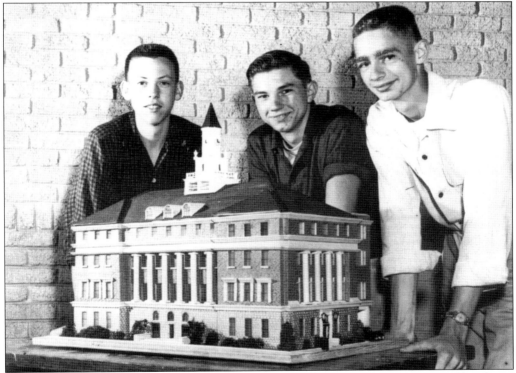

In 1954 Hagerstown High School students built this model of Hagerstown's City Hall and sent it to an exhibit in Wesel, Germany. Wesel has been Hagerstown's sister city since 1952. Wesel Boulevard, which links the shopping centers between the Valley Mall and Burhans Boulevard, was named in honor of the city. Today, the annual Augustoberfest celebrates this link between the two cities. The boys are, from left to right, Robert Mann,Hugh Snively, and Donald Kreh. (Courtesy *Maryland Cracker Barrel*.)

13

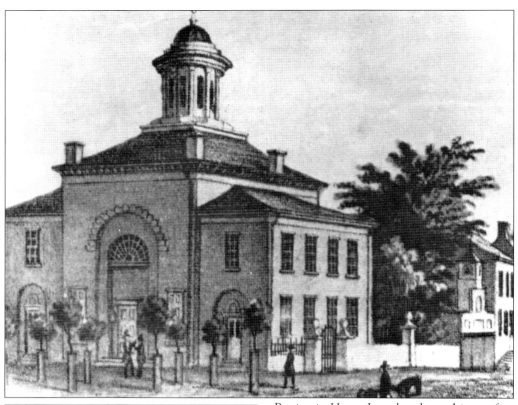

Benjamin Henry Latrobe, the architect of the U.S. Capitol, designed the second Washington County courthouse, seen above, in 1816. General McCausland and town officials resolved the Ransom of Hagerstown in this building in 1864. A fire devastated the 50-year-old structure, located on the corner of Summit Avenue and East Washington Street, on December 5, 1871. (Courtesy *Maryland Cracker Barrel*.)

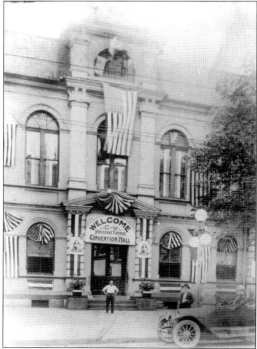

Taken on July 4, 1917, this photograph shows the courthouse decked out in patriotic bunting. Uncle Sam recruiting posters on either side of the doors remind us that World War I was in full swing at this time. This structure, the third and present-day courthouse, was built in 1873 on the same site as the second courthouse that burned down; it was dedicated in 1874. (Courtesy Washington County Historical Society.)

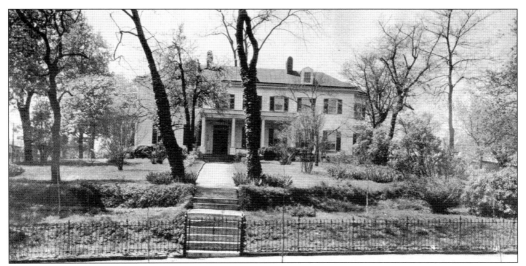

Built in 1789 by Nathaniel Rochester, the Rochester House was also known as Mount Prospect. Nathaniel Rochester, the founder of the city of Rochester, New York, served as the first president of Hagerstown's first bank. A former colonel in the Continental Army, Rochester owned a nail and lock factory, and also served as postmaster, sheriff, and county court judge during his years in town. He left Hagerstown in 1810 for the Genesee Valley in New York State. (Courtesy Western Maryland Room, Washington County Free Library.)

Mount Prospect stood proudly at the corner of Prospect and Washington Streets for many years; it was torn down in 1956 and replaced by a parking lot. During the Civil War, the house served as a way station for wounded from both the North and the South. Oliver Wendell Holmes Jr., later chief justice of the U.S. Supreme Court, was wounded at the Battle of Antietam and treated here. (Courtesy Western Maryland Room, Washington County Free Library.)

15

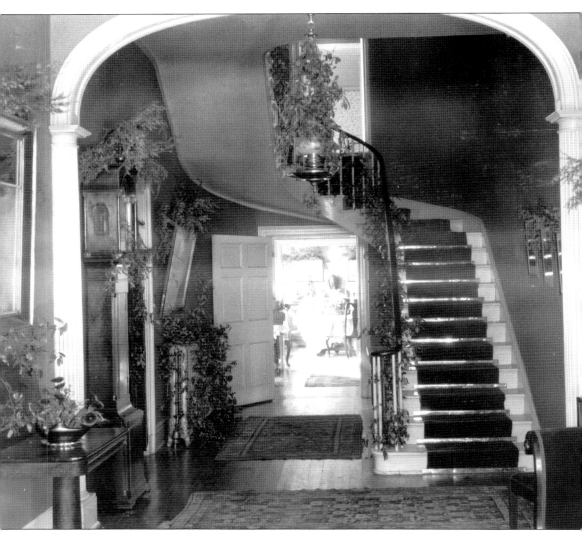

Originally built in 1818, the red brick townhouse known as the Miller House is now home to a museum as well as the Washington County Historical Society. The Federal-style building seen today dates from 1824. This photograph shows the interior of the home decorated for the holidays. The elegant, cantilevered stairway is as graceful today as in the 19th century. (Courtesy Washington County Historical Society.)

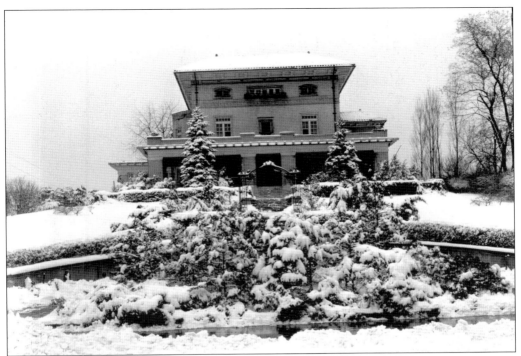

The Byron home, which belonged at one time to the Byron family that owned the tannery in Williamsport, is shown here on North Potomac Street and is just one of the many large, historic houses found in Hagerstown. Some of the oldest are found on North Potomac Street, on Virginia Avenue near City Park, on The Terrace and Oak Hill Avenue, and the historic preservation area of South Prospect Street. These homes stand in tribute to the heyday of prosperity in Hagerstown. Today, while some are still occupied as single-family homes, many others have been converted to apartments or offices. (Courtesy Washington County Historical Society.)

These Victorian gables on top of the Merrick-Stonebraker home on Oak Hill Avenue are just one of the many fine architectural elements found on buildings throughout Hagerstown. (Courtesy Washington County Historical Society.)

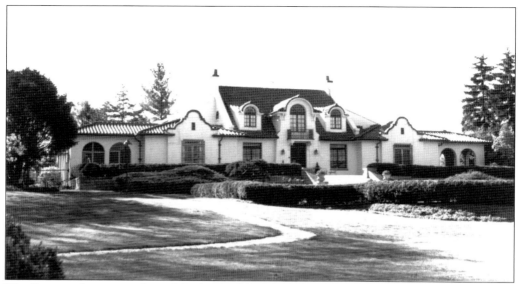

The Bowman house, another of the large, older homes found in Hagerstown, is located on The Terrace and belonged to Dr. H.D. Bowman c. 1916–1918. (Courtesy Washington County Historical Society.)

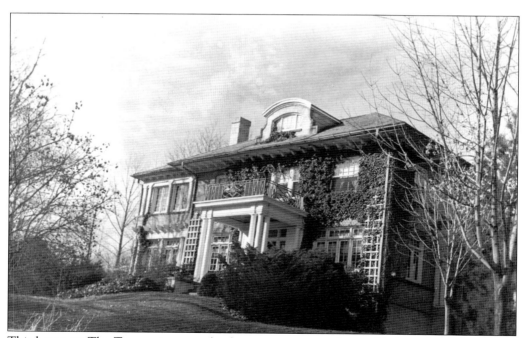

This home on The Terrace is a completely cement construction and belonged to John Porter, the president of North American Cement, now the Martin Marietta Corporation. (Courtesy Washington County Historical Society.)

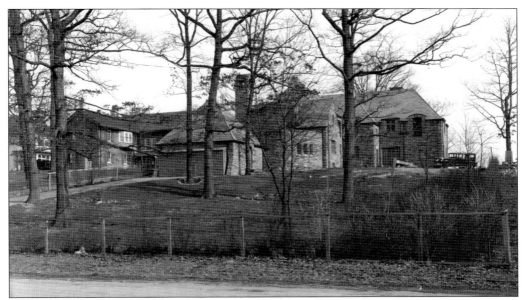

This rear view shows the impressive size of "Journey's End" on The Terrace, a home belonging to Thomas Pangborn. The Pangborn Company, built on the development of a process for blast cleaning foundry products, has been a staple in Hagerstown since it opened in 1912. Everyday products, such as cars and stoves, must be cleaned of the residue that results from mass production, and it was Pangborn's initiative that made this possible. After many, many years in business, the Pangborn Company has just recently closed its doors. (Courtesy Washington County Historical Society.)

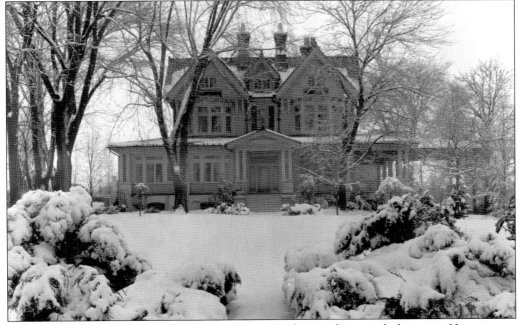

A heavy blanket of snow provides a scenic setting for another stately home in Hagerstown. (Courtesy Washington County Historical Society.)

A native of Washington County, William T. Hamilton once lived in this Georgian home. He was admitted to the bar in 1843, was later elected to the House of Delegates in Annapolis, and then to the U.S. Senate in 1864. Hamilton was also elected governor of Maryland, a position he held from 1880 to 1884. This house was taken down in later years to build St. Mary's School. (Courtesy Western Maryland Room, Washington County Free Library.)

Born in Hagerstown, William Preston Lane was elected governor of Maryland in 1947. One of his most memorable accomplishments as governor was a tax he instituted to raise funds for, among other things, the construction of the Chesapeake Bay Bridge. The seven-mile bridge was later renamed the William Preston Lane Jr. Memorial Bridge. This photograph shows the Lane family home at 943 The Terrace in Hagerstown. (Courtesy Washington County Historical Society.)

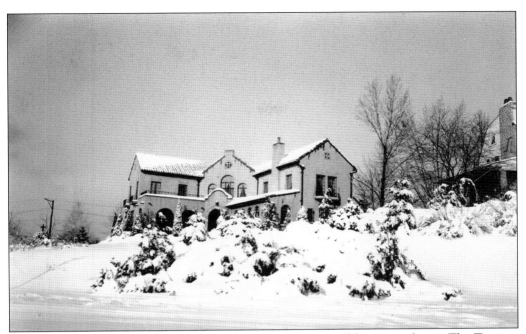

This imposing home, known as the Funkhouser House, can still be seen today on The Terrace. (Courtesy Washington County Historical Society.)

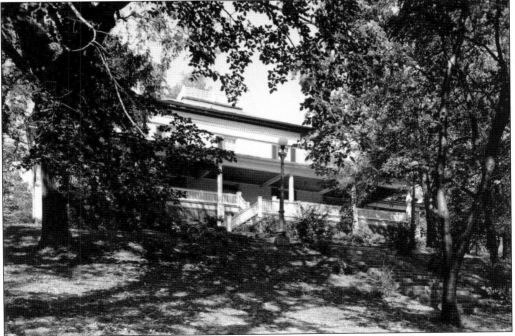

Only six people ever owned the land now contained in City Park before the City bought the land in 1915. One of these was John Heyser, a miller and artist, who produced wine from his own vineyard. Heyser began building his home, known as the Mansion House, in 1842 and it was completed three years later. (Courtesy Washington County Historical Society.)

This vintage photograph provides a view of East Avenue, looking east from North Potomac Street, in 1893. (Courtesy Washington County Historical Society.)

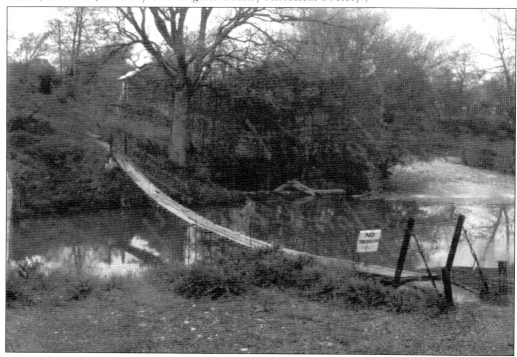

Hagerstown has many bridges throughout town. One of the more unusual is this swinging footbridge over Antietam Creek near Security Road, pictured c. 1975. (Courtesy Washington County Historical Society.)

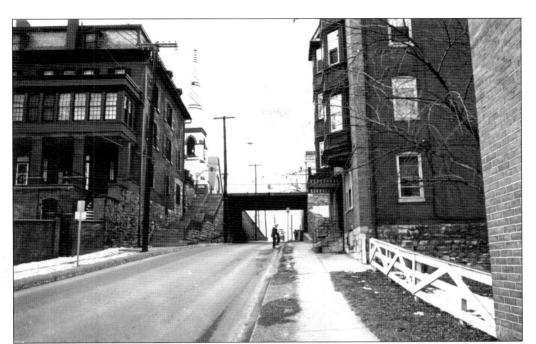

This view, looking west, shows Antietam Dry Bridge, which was originally built as a stone bridge in the mid-19th century. The structure crossed the Antietam Street ravine and opened up Southern Prospect Hill for development. The stone bridge was later replaced by the iron structure and archway that now graces historic Prospect Street. (Courtesy Washington County Historical Society.)

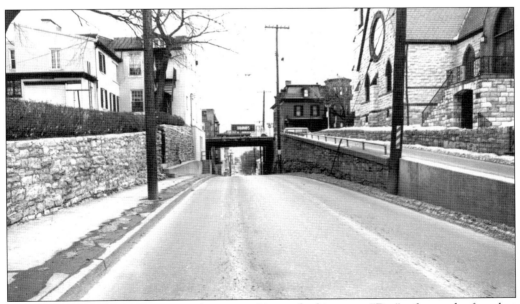

Antietam Dry Bridge is seen in another view, this one looking east. "Dry" refers to the fact that the bridge does not span any waterway. The large Gothic Revival church on the right is St. John's Episcopal Church, built in 1872. (Courtesy Washington County Historical Society.)

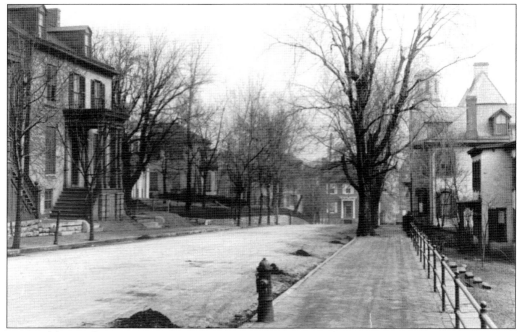

Pictured here is historic Prospect Street as it appeared around 1917. The Women's Club can be seen on the left with stairs leading up to a columned porch. (Courtesy Washington County Historical Society.)

Another view of Prospect Street, taken from the rear on February 21, 1917, is seen above. Note the chicken roaming around near the fencepost in the lower left of the image. (Courtesy Western Maryland Room, Washington County Free Library.)

In the early 1800s Oak Spring was located on the corner of North Potomac and Franklin Streets, one block west of the new City Hall. When people came to the City Market, which was held on the first floor of the City Hall, they watered their horses at this spring known for its sweetness and purity. Oak Spring was covered when the Pioneer Hook and Ladder built their fire station over it in 1872. (Courtesy Washington County Historical Society.)

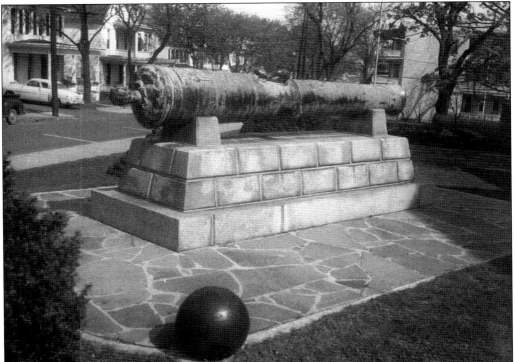

This Spanish war cannon, located on the corner of North Potomac and North Streets, represents the only memorial park in the United States dedicated to veterans of the Spanish-American War. Made in 1751, the cannon is thought to have been used in Napoleon's wars and then taken to Spain. The Spaniards brought it to Cuba, where it was captured during the fighting in 1898. (Courtesy Washington County Historical Society.)

Taken in 1952, this photograph shows the Old Loose Farm on Security Road. Well into the 1950s Hagerstown was still very much an agricultural community, and the sprawl of construction emanating from downtown had not yet begun. (Courtesy Washington County Historical Society.)

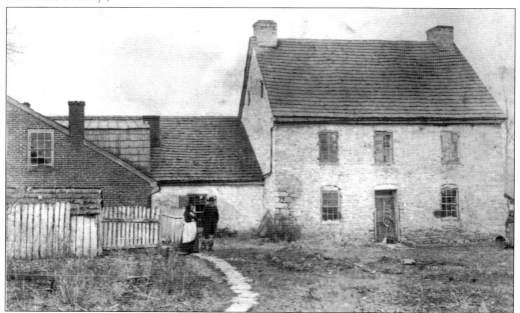

Built in 1750, Downey's Lott, the property of J.S. Downey, was located on Leitersburg Pike facing Long Meadow. Note the sturdy stone construction and the method of joining the buildings. A girl with a broom stands in the doorway while an older couple comes down the path. (Courtesy Washington County Historical Society.)

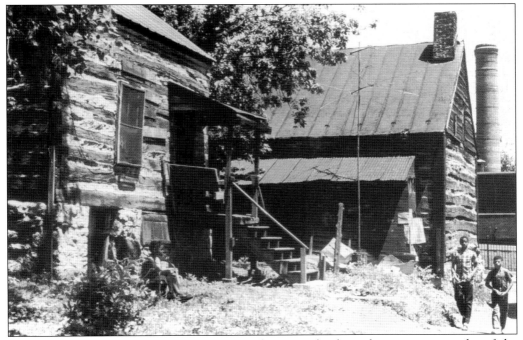

Braxton Alley in downtown Hagerstown was home to this log cabin, a rare reminder of the more humble homes that stood in contrast to the expensive homes found elsewhere in town. (Courtesy Washington County Historical Society.)

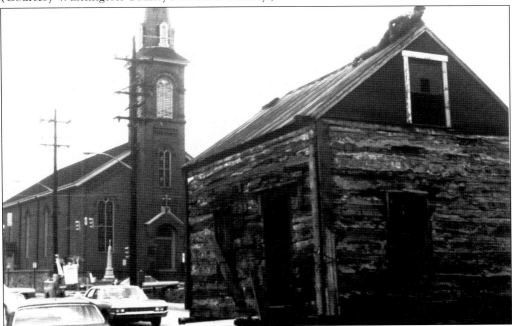

During the late 1950s/early 1960s, the old log cabin that had stood in Braxton Alley was loaded on a truck and moved through town. St. Mary's Catholic Church is in the background of this picture. (Courtesy Washington County Historical Society.)

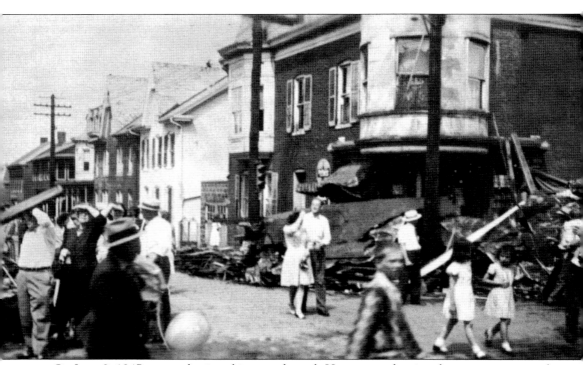

On June 9, 1947 a tornado ripped its way through Hagerstown leaving devastation in its wake. The storm, just one of several severe weather events that month, caused approximately $500 thousand worth of damage. This image shows the corner of South Mulberry and Antietam Streets after the storm. (Courtesy *Maryland Cracker Barrel*.)

Two

THE PUBLIC SQUARE VICINITY

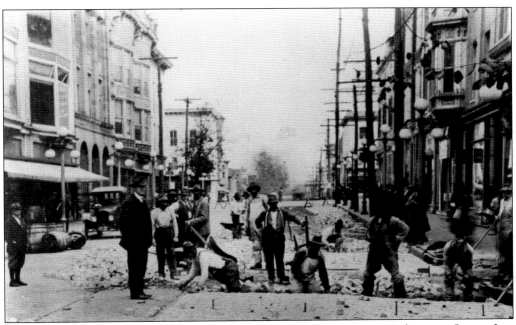

In this c. 1915 photograph men lay granite paving blocks on West Washington Street. Just behind them, sawhorse barriers mark the edge of the Public Square. Note the trolley tracks in the center of the street. Hoffman's store is on the left; the building next door to it (with the arches) is 2nd National Bank. Eyerly's Department Store is located where the large awning extends over the sidewalk. Eyerly's would later move, along with Montgomery Ward, to the new Valley Mall built in the Halfway area of Hagerstown during the 1970s. While Wards closed after over 120 years in business, Eyerly's is still in the mall but its name has been changed to The Bon-Ton. (Courtesy Washington County Historical Society.)

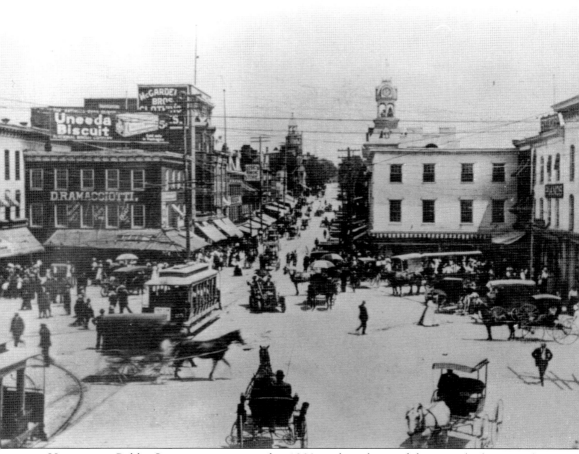

Hagerstown Public Square, as it appeared c. 1900, is the subject of this view looking north on Potomac Street. Note the throngs of people and the hustle and bustle of the thriving town. Trolleys roll down the middle of the street, horse-drawn vehicles are parked everywhere, and there is a very early motorcar in the center to the right of the trolley. The clock tower of city hall can be seen up the street on the right, and the steeple of the Zion Reformed Church further up the street on the left. D. Ramacciotti's fruit and candy store dominates the left side of the square, and Rose's Shoe Store is also just up the street on the left. Note the five-cents advertisement for Uneeda Biscuit. Awnings were the order of the day, overhanging the pavement on most businesses. (Courtesy Washington County Historical Society.)

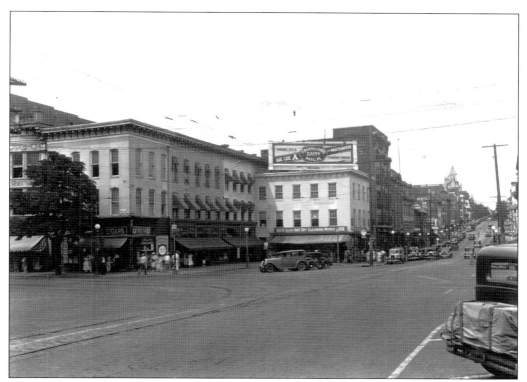

This view shows the same corner of the public square in the 1930s. The billboard is still in place but now it advertises milk from the Hagerstown Dairy. The trolley tracks are also still there but the traffic is entirely motor vehicles. (Courtesy Washington County Historical Society.)

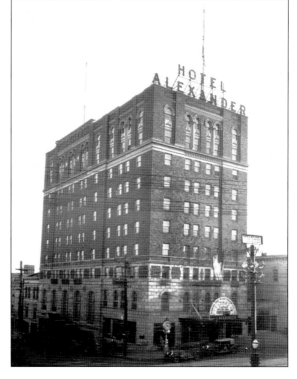

The imposing Hotel Alexander, one of several large hotels serving Hagerstown, dominated the public square and boasted a ballroom and banquet hall. Brisk railroad business brought prosperity to Hagerstown and allowed the town to support large hotels such as this; if not for the railroad, Hagerstown would not have had the same boom era. The R. Bruce Carson clock is in front of the hotel (the jewelry store occupies a street level portion of the hotel), and the Blue Ridge Bus Terminal can be seen down the street toward the back of the hotel. (Courtesy Washington County Historical Society.)

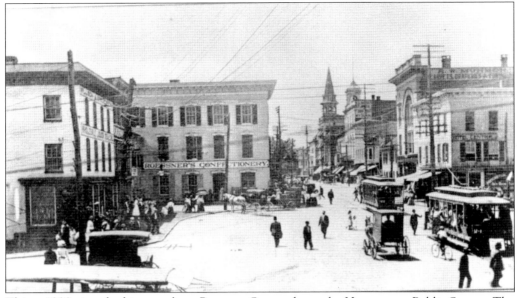

This *c.* 1900 view, looking south on Potomac Street, shows the Hagerstown Public Square. The Central Hotel is on the right, and Roessner's Confectionery is on the left. The Alexander Hotel had not yet been built and the buildings found on its future location on the left include Willson & Stevenson Wholesale Liquor Dealers, Charles E. Shenk's Piano and Music Store, and an optician's office. J.W. Munson's Carpets, Draperies & Furniture Store is on the right side of the street, and the steeple of St. John's Lutheran Church can be seen farther down the street. (Courtesy Washington County Historical Society.)

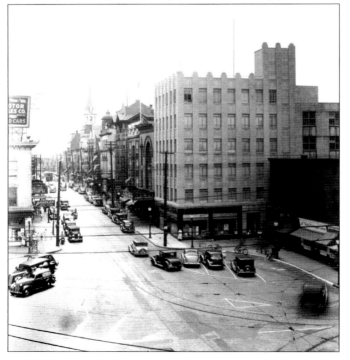

On the public square, seen here in the 1930s in a view looking south on Potomac Street, People's Drug Store is on the left and the multi-storied Professional Arts Building is on the right. The Colonial Theater is visible on the left and the Maryland and Henry Theaters are across the street. Note the trolley in the distance and the spire of St. John's Evangelical Church. At this time, these streets were two-way thoroughfares instead of the current one-way system. (Courtesy Washington County Historical Society.)

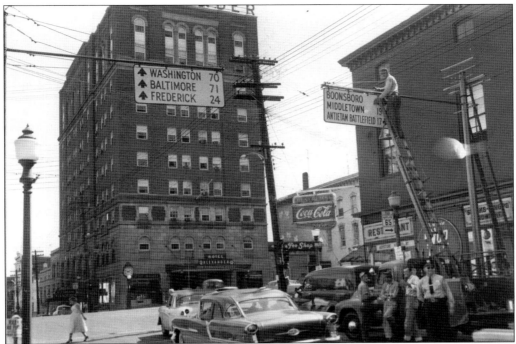

Photographed on September 25, 1957, the public square in downtown Hagerstown had these directional signs pointing the way. Travelers could head straight out on Washington Street (U.S. Route 40) and not stop until arriving in Frederick or Baltimore, while a left turn on Potomac Street would take them right to Antietam. (Courtesy Western Maryland Room Washington County Free Library.)

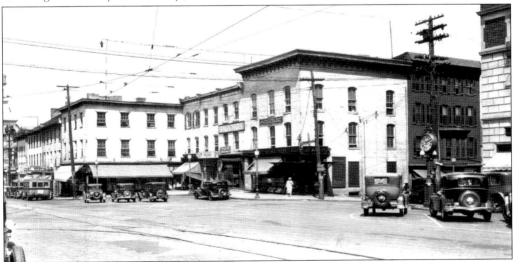

Trolley tracks still ran down the center of the street in this 1934 snapshot of the public square, looking north up Potomac Street with East Washington to the right. The historic R. Bruce Carson clock is seen on the corner in front of the Hotel Alexander. Today the Hagerstown-Washington County Convention and Visitor's Bureau occupies the building on the left of the picture with the large awnings. (Courtesy Washington County Historical Society.)

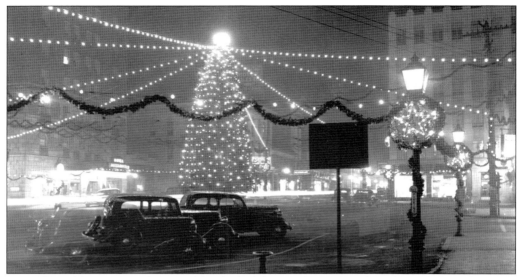

Here, the public square is decorated for the holidays in the 1940s. The Alexander Hotel rises on the left, and the top of the clock, a town landmark found outside R. Bruce Carson's jewelry store, can just be seen above the lights. The Professional Arts building is the tall structure on the right. People's Drug Store was located on the east side of the street at the time of this photograph and the lit sign can be made out on the right side of the tree. The Keystone Soda Fountain and Restaurant on the west side of the street was torn down c. 1958 and People's Drug Store and lunch counter was moved. Today, the drug store is gone and there is no longer a center roundabout in the square. (Courtesy Washington County Historical Society.)

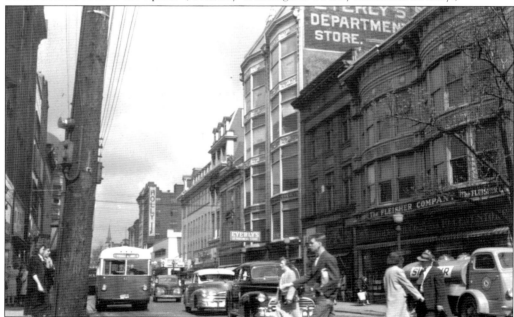

In this photograph just a few of downtown's many stores, including Eyerly's, Fleisher's, and the Holly store, are visible. This image was taken in the post-trolley days as the local bus can be seen coming up the street. (Courtesy Washington County Historical Society.)

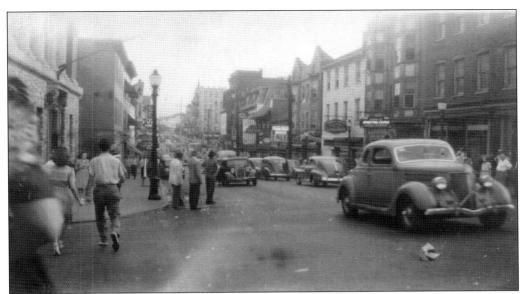

Cars and people crowd North Potomac Street in downtown Hagerstown at 7:30 p.m. on V-J Day, August 14, 1945. (Courtesy Western Maryland Room Washington County Free Library.)

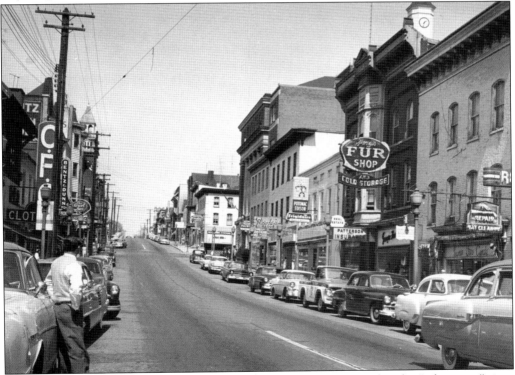

North Potomac Street is seen on April 18, 1959, just three minutes after the "take cover" siren began its wail as part of a nation-wide air defense alert drill. While not everyone took cover, including the photographer and the man standing by the car, traffic certainly came to a halt. (Courtesy Western Maryland Room, Washington County Free Library.)

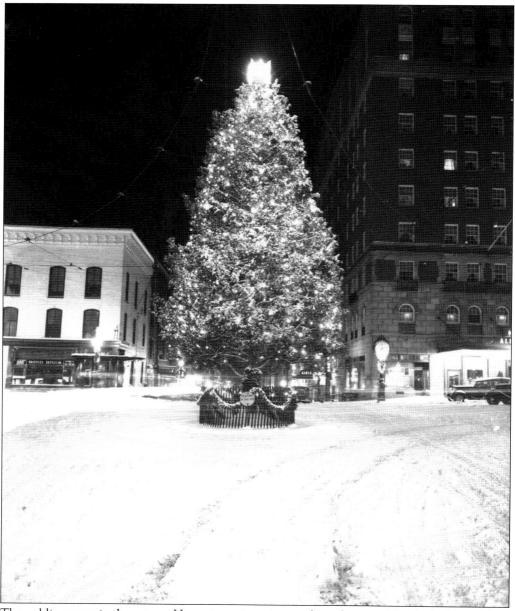

The public square in downtown Hagerstown is again seen here decorated for the holidays. Note the snow that covers the roadway and the signs of the traffic that had come through, evidence of the days when all shoppers came downtown to make their purchases. (Courtesy Washington County Historical Society.)

Three

TRANSPORTATION AND INDUSTRY

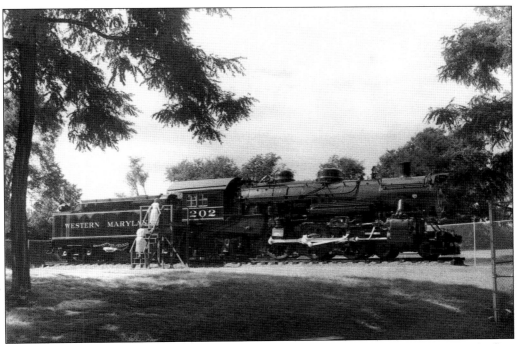

Steam Engine 202 of the Western Maryland Railroad is on display in Hagerstown's City Park. The engine was built in 1912 by the Baldwin Locomotive Works and is the only Western Maryland road-type steam locomotive still in existence. The locomotive hauled mail, passengers, and baggage from Baltimore to Hagerstown and was retired in 1953. (Courtesy Washington County Historical Society.)

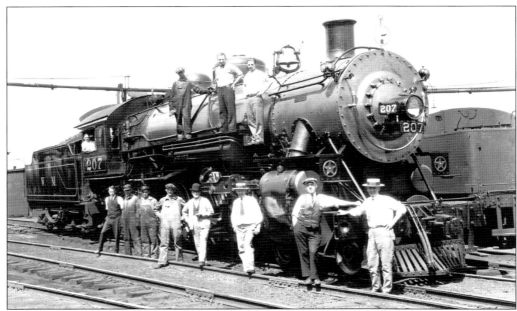

The Western Maryland Railroad was chartered in 1852 and, by 1887, there were two Western Maryland passenger terminals in Hagerstown, a freight station, train yards, and two grain elevators. Tracks from the Western Maryland served town from the north, south, and east and connected with all other railroads. (Courtesy Washington County Historical Society.)

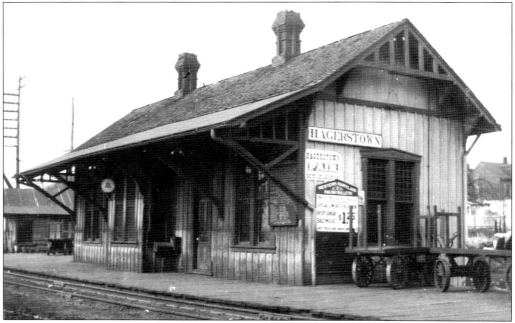

This is how the Western Maryland train station looked before it was replaced in June 1913. The new structure still stands today and serves as the Hagerstown Police headquarters. The old building was dismantled and moved to Hanover, Pennsylvania. (Courtesy Washington County Historical Society.)

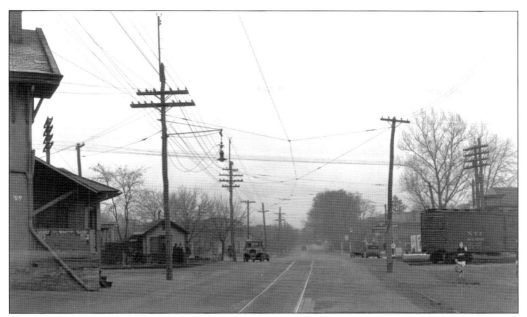

This 1930s view of the intersection of Potomac Street and Hamilton Avenue shows a brick road with trolley tracks down the middle. The old Western Maryland Station can just be seen off to the left. Many trains left from this station for the extremely popular Pen Mar Park. (Courtesy Washington County Historical Society.)

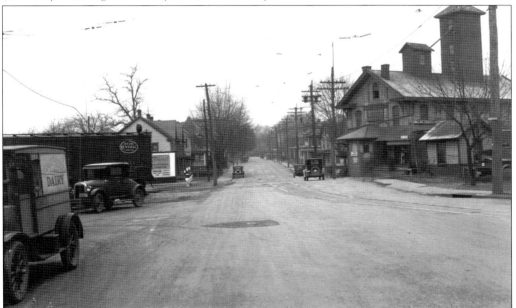

This is another view of the intersection of Potomac and Hamilton Streets seen from the opposite direction during the 1930s. The Potomac Avenue station and grain elevator of the Western Maryland Railroad are on the right and a boxcar from the New York Central Line is on the left. Also visible is a delivery truck from the Grand-View Dairy. (Courtesy Washington County Historical Society.)

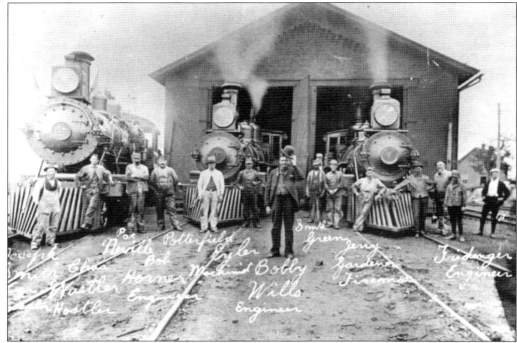

The old Western Maryland Roundhouse was located off old Elizabeth Street (now Burhan's Boulevard) in Hagerstown. Here are many of the engineers and firemen that kept these old engines running. (Courtesy *Maryland Cracker Barrel*.)

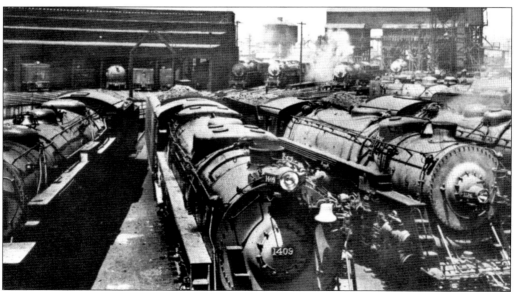

The Western Maryland Railway Roundhouse is pictured here at the height of the steam age. The roundhouse is packed and very busy! (Courtesy *Maryland Cracker Barrel*.)

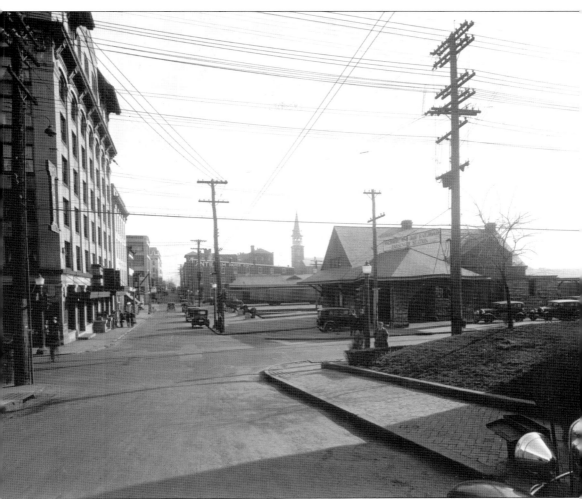

The Baltimore & Ohio Passenger Railroad Terminal was located on the corner of Summit Avenue and Antietam Street. The B&O was just one of several railroads that came into Hagerstown. Others included the Western Maryland Railroad, the Penn Central, and the Norfolk & Western. With all these lines coming in to Hagerstown from all directions, Hagerstown began to look like a wheel and the tracks spokes stretching out from Hagerstown at the center. This was the beginning of Hagerstown's nickname "Hub City." Today, passenger service is gone and the *Herald-Mail* newspaper occupies the site of the B&O terminal. (Courtesy Washington County Historical Society.)

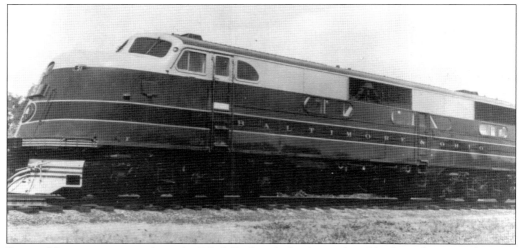

Pictured here is an engine from the B&O Railroad, the first railroad built in the United States. It was intended to transport goods much faster than the canal or wagon trains. (Courtesy Washington County Historical Society.)

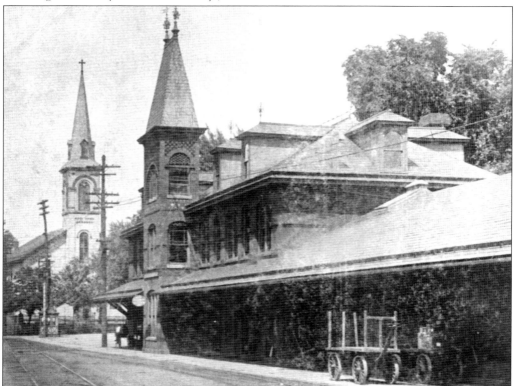

The Cumberland Valley Railroad Station is seen in 1920 on the corner of West Washington Street and Walnut Lane. St. Mary's Catholic Church is on the corner, across the street from the station. The Pennsylvania Railroad eventually took over the Cumberland Valley line, and today, Walnut Lane follows the route of the old tracks. Walnut Towers, senior citizen housing, is now on both sides of the street. (Courtesy Washington County Historical Society.)

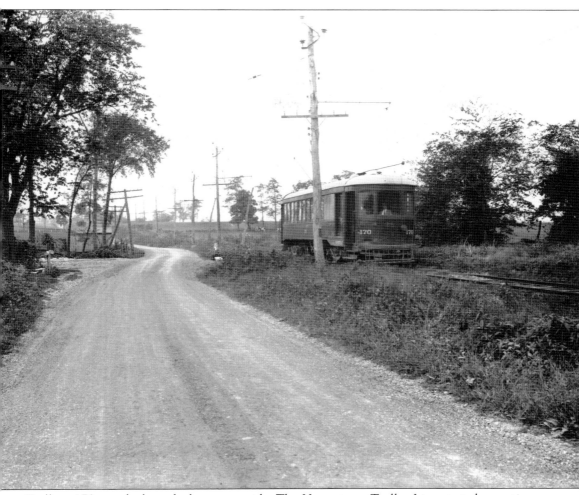

Trolley #170 travels through the countryside. The Hagerstown Trolley Line started operation in 1896 and reached its height of service as the Hagerstown and Frederick Railway between 1913 and 1926. By 1904 the trolley was running 29 miles over mountainous roads to link Hagerstown and Frederick, and few years later, the lines ran to Chambersburg, Pennsylvania. In the 1920s, the growth in popularity of cars and buses resulted in a decline in trolley passengers. Service was finally discontinued on the last of the operating routes in August 1947. (Courtesy Washington County Historical Society.)

Another quiet scene shows the trolley tracks making their way through the countryside past fields and barns. (Courtesy Washington County Historical Society.)

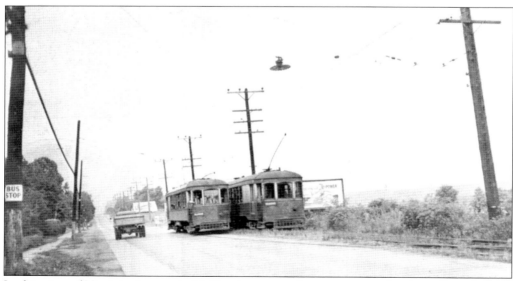

In this view of Virginia Avenue in Halfway's younger days, a crossover for the trolleys that ran up Virginia Avenue to Williamsport can be seen. (Courtesy Maryland Cracker Barrel.)

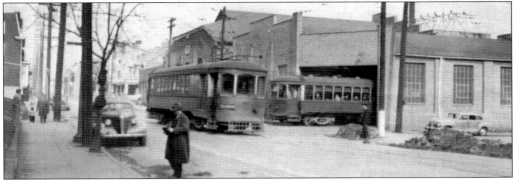

The Potomac Edison trolley car barn was located on the corner of Summit Avenue and Lee Street. The building, previously a powerhouse, still stands today and is easily recognizable, though it has been many years since the trolleys nosed their way in and out of the building. The original car barn was located on Summit and Howard Streets, but a fire destroyed it on March 20, 1917. (Courtesy *Maryland Cracker Barrel*.)

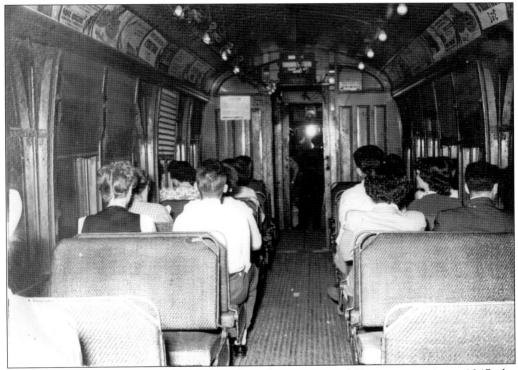

In this interior view of one of the many trolleys that crisscrossed Hagerstown prior to 1947, the windows have shades, advertising lines up overhead, and light is provided by the bulbs hanging along both sides of the curved ceiling. (Courtesy Western Maryland Room, Washington County Free Library.)

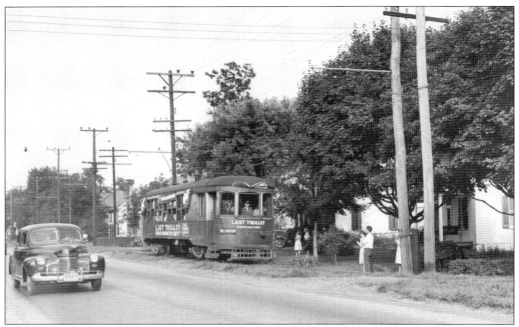

In 1947, after many years of service, the trolleys stopped running in Washington County. Decked out in bunting for its historic trip, the last trolley is seen stopped along the Hagerstown-Williamsport route on Virginia Avenue in the Halfway area. Note how close to the front of the houses the trolley tracks ran. (Courtesy Washington County Historical Society.)

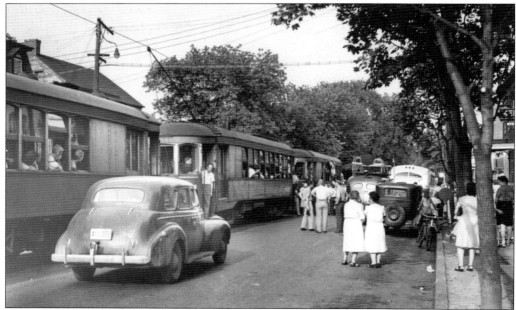

Here we see a mix of the old and new. The trolley cars are at the Williamsport end of the last trolley trip. Near the center of the photo is the WJEJ radio station sound truck and on the right can be seen the rear of the first bus that would begin service throughout town. (Courtesy Washington County Historical Society.)

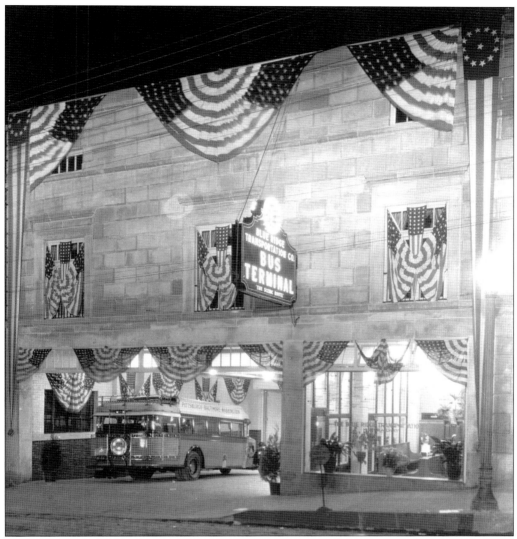

Taken on March 30, 1929, this photograph celebrates the opening of the Blue Ridge Transportation Company's Hagerstown Bus Terminal. The Potomac Edison Company built the new terminal in cooperation with the Alexander Hotel Corporation. The terminal adjoined the hotel and opened onto East Washington Street. The second floor had a ballroom and banquet hall for the hotel. There is a large route map on the front glass window showing the Blue Ridge Line's entire "Scenic Route." In later years, this terminal closed and Hagerstown began to be served by the large Greyhound terminal on East Antietam Street. In recent years, this terminal was also closed due to declining use and it moved to a much smaller terminal on Route 65, near Interstate 70. The Greyhound bus terminal is now the Washington Spy restaurant, presumably named for Hagerstown's first paper, published in 1790. The original terminal on East Washington Street is now the NBC 25 television station. (Courtesy Washington County Historical Society.)

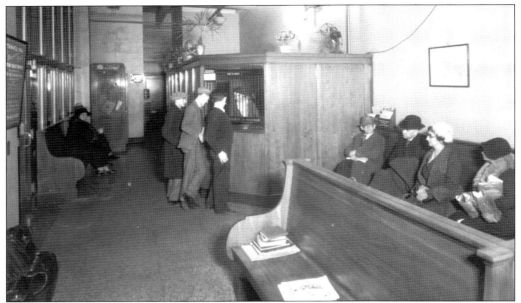

The waiting room and ticket office of the Blue Ridge Terminal of the Potomac Edison Bus Company had high-backed walnut benches that faced the windows to allow travelers to view the incoming buses. (Courtesy Washington County Historical Society.)

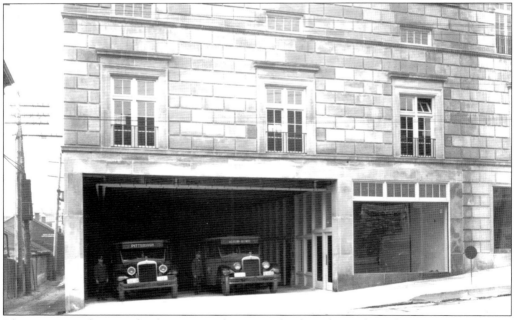

This vintage photograph shows two drivers with their buses bound for Pittsburgh and Hagerstown-Baltimore parked in the Blue Ridge Bus Terminal on East Washington Street. Buses entered the terminal through a 30-foot-wide door and 6 coaches could load and unload simultaneously. At this time (c. 1929), only two other cities in the East had bus terminals—New York and Baltimore. Buses ran daily from Baltimore and Washington through Hagerstown to Pittsburgh. (Courtesy Washington County Historical Society.)

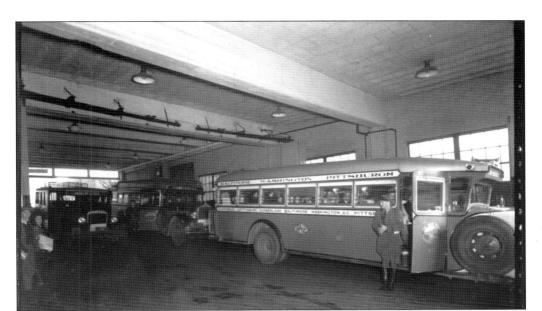

Those great old buses are ready to load and unload passengers inside the Blue Ridge Bus Terminal. Baltimore, Washington, D.C., Pittsburgh, Cumberland, Maryland, and Harrisburg, Pennsylvania are just a few of the destinations proclaimed on the buses. (Courtesy Washington County Historical Society.)

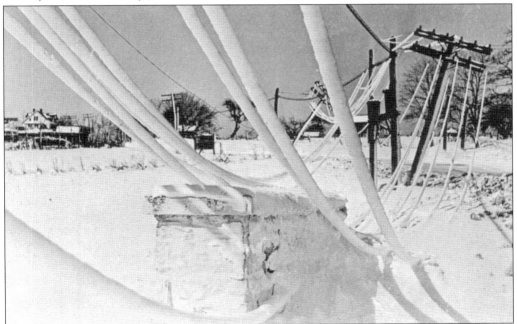

While there have been other winter storms that have occurred just as spring was approaching, one of the most memorable was the raging storm that hit Hagerstown on March 27, 1932. Power was out all over the area, and this photograph, taken along old Route 40, shows the depth of the snow. This appears to be one of the old Blue Ridge buses stuck under the snow and downed power lines. (Courtesy *Maryland Cracker Barrel.*)

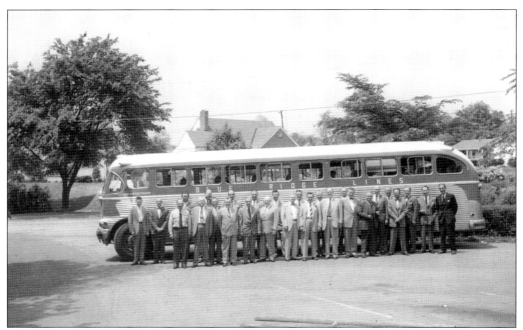

Employees stand proudly in front of one of the air-conditioned Blue Ridge buses. (Courtesy Western Maryland Room Washington County Free Library.)

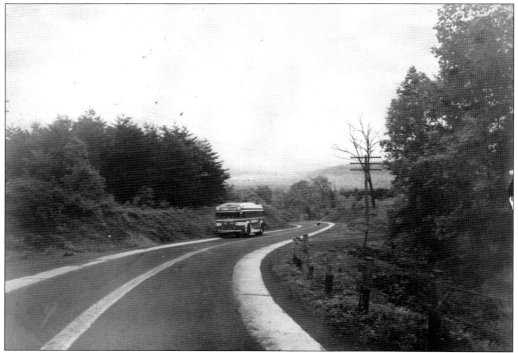

While the buses have changed, the mountain scenery is still there. Here one of the Blue Ridge Line buses winds its way west up the mountain on Alternate Route 40 en route to Hagerstown. (Courtesy Western Maryland Room, Washington County Free Library.)

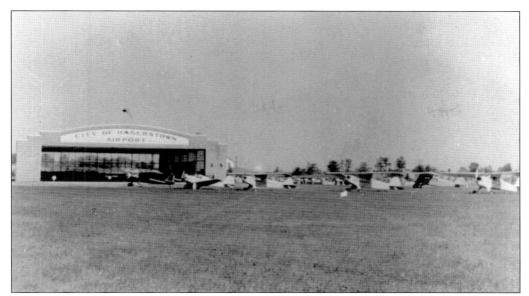

Dedicated on June 19, 1938, Hagerstown Municipal Airport previously belonged to the Fairchild Aircraft Co. This 1938 structure serviced all commuter passenger needs for the airport until 1991 when a new terminal was dedicated on a site across the field at the airport. Now known as Washington County Regional Airport, it serves the entire tri-state area of Maryland, Pennsylvania, and West Virginia. (Courtesy Washington County Historical Society.)

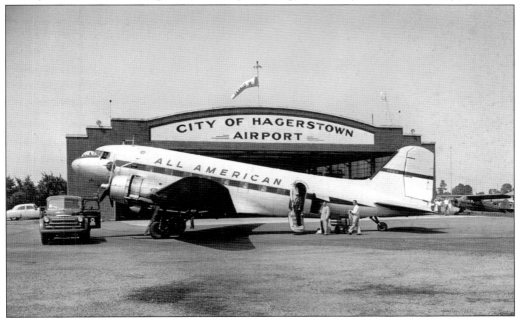

A plane from All American Airlines waits outside the hangar at the Hagerstown Airport on U.S. Route 11, north of town, in the mid-1950s. Texaco was the fuel of choice as noted on a windsock above the hangar. In later years, All American became known as Allegheny Air Lines and, in October 1979, became USAir, the airline that still operates commuter service from the airport today. (Courtesy Western Maryland Room, Washington County Free Library.)

One of Hagerstown's largest industries had its humble beginnings in the old shed of a back lot of Pennsylvania Avenue. Lou and Harry Reisner built their first airplane in the basement of their home on Belview Avenue. While their parents helped as much as possible and this shed took the place of the basement, money for continued improvements on the plane was not available. Ammon Kreider, a former pilot and the president of a Hagerstown shoe company, offered his assistance and the Kreider-Reisner Aircraft Company was founded in the late 1920s. In later years, from this unassuming start, the company became the world famous Fairchild Aircraft Company. (Courtesy Western Maryland Room, Washington County Free Library.)

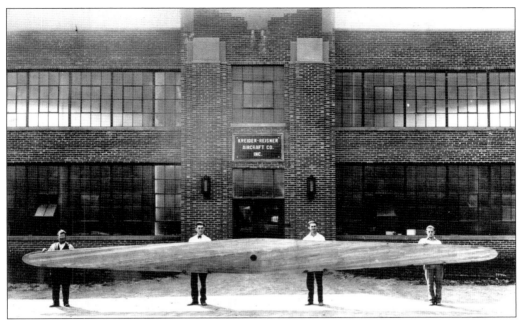

Note the size of the wooden airplane propeller these men are holding outside the Kreider-Reisner Aircraft Company located at 1 Park Lane. The plant was completed in 1929 and was used by Fairchild until 1963. (Courtesy Washington County Historical Society.)

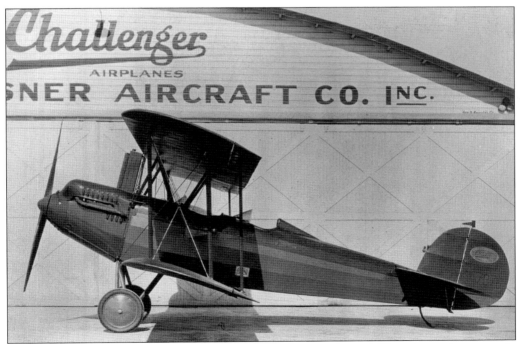

This Challenger biplane, parked outside the Kreider-Reisner Aircraft Plant, is another example of the planes built by the company. (Courtesy Western Maryland Room, Washington County Free Library.)

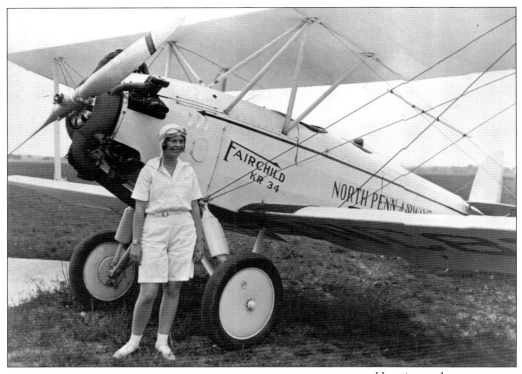

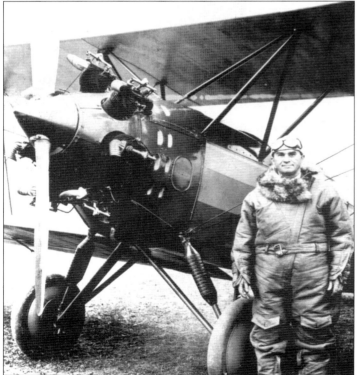

Here is another Fairchild/Kreider-Reisner plane from North Penn Airways. Women have been as eager to take to the skies as their male counterparts since the early years of aviation, and this woman stands proudly by the biplane. (Courtesy Western Maryland Room, Washington County Free Library.)

Ammon Kreider, one of the founders of Kreider-Reisner, stands by a Challenger C-4. He is bundled up warmly for open-cockpit flying in the traditional flight suit of the day. A copy of this photograph once hung in the Kreider-Reisner plant. (Courtesy *Maryland Cracker Barrel.*)

This aerial view of a Fairchild F-27 in flight also shows a gentleman in the foreground taking instrument readings. (Courtesy Western Maryland Room, Washington County Free Library.)

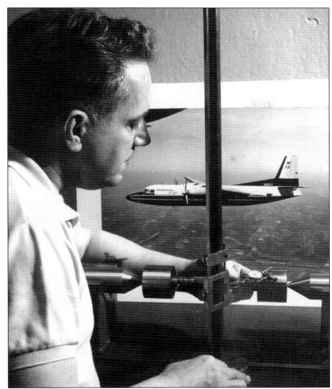

This Fairchild plane was built around the late 1920s and is parked outside the Fairchild hangar. Fairchild's most famous plane was the C-82 Flying Boxcar designed for cargo and airborne troop operations during World War II. It was instrumental in providing relief air during the Berlin Blockade. (Courtesy Washington County Historical Society.)

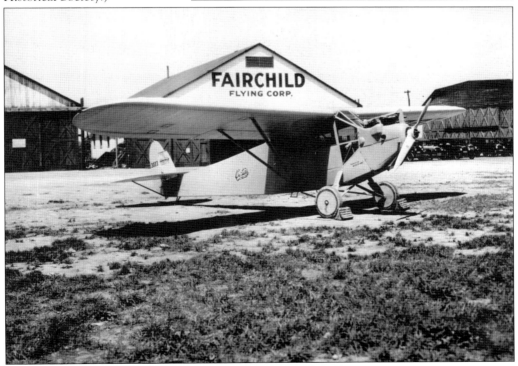

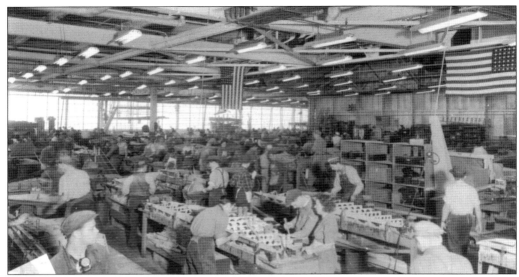

In this interior view of the Fairchild Aircraft Plant during World War II a woman appears in the middle foreground; women took an active part in meeting the critical needs of industry during the war years. Almost all World War II pilots learned to fly on the PT-19 or Cornell training plane built at Fairchild. During 1940, production levels reached three planes per day! The company employed 8,000 workers at its peak in 1943, and about 80 percent of Hagerstown's population was working directly or indirectly in the aircraft industry. The war effort had closed down many other businesses, and many were put into emergency service for the war effort. Moller Pipe Organ, for example, used their plant to build wing assemblies for Fairchild planes. (Courtesy Washington County Historical Society.)

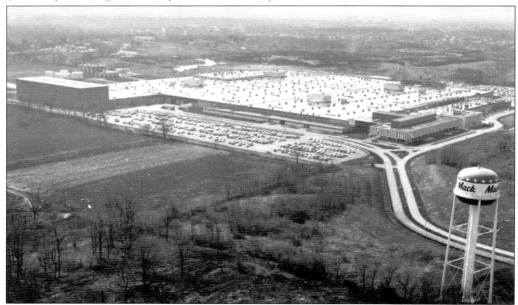

Originally incorporated in 1901, Mack Trucks came to Hagerstown in 1962 when the company built this multi-million-dollar plant off Maugans Avenue and became the region's largest employer at that time. (Courtesy Washington County Historical Society.)

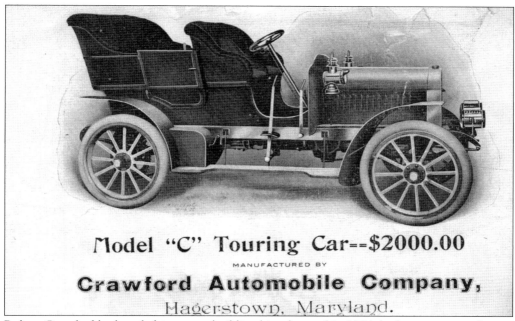

Model "C" Touring Car==$2000.00

MANUFACTURED BY

Crawford Automobile Company,

Hagerstown, Maryland.

Robert Crawford had made his money building bicycles, and in 1904, he began to manufacture automobiles. Though production continued until 1922, a limited number of vehicles were manufactured and Crawford's success was somewhat marginal. Mathias Moller bought controlling interest in the company in 1922 and began producing Dagmar cars. This is an early advertisement for the Crawford automobile. (Courtesy Washington County Historical Society.)

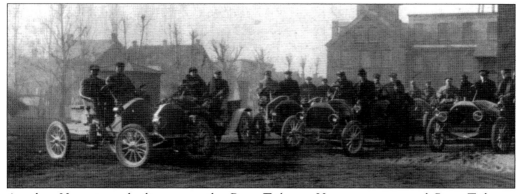

Another Hagerstown-built car was the Pope Tribune. Here we see several Pope Tribunes that have just been built, *c.* 1910, in the factory on Pope Avenue. (Courtesy *Maryland Cracker Barrel.*)

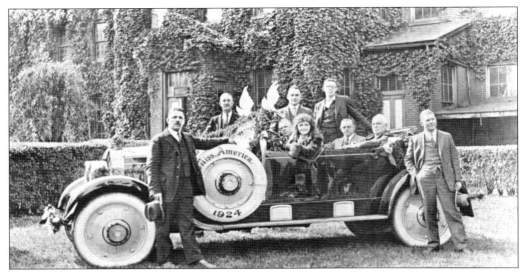

Featured here is a Dagmar 6-70 Victoria Speedster that was presented to Miss America. Moller is seated in the rear on the right. The Dagmar, named for Moller's daughter, was an expensive and luxurious motorcar for its day. Famed actress Gloria Swanson was one of the proud owners of a Dagmar. (Courtesy *Maryland Cracker Barrel*.)

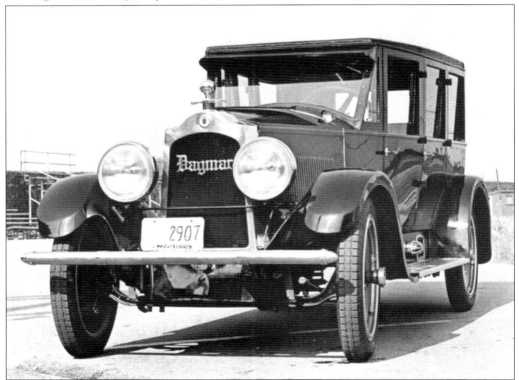

The 1925 Dagmar car shown here has often been showcased at the Valley Mall during historic automobile displays. It is one of only two known restored Dagmars in existence. (Courtesy Maryland Cracker Barrel.)

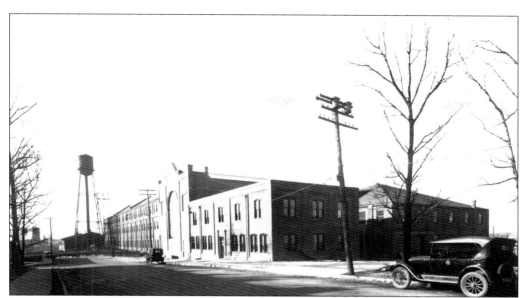

Mathias P. Moller, who would go on to produce the Dagmar line of automobiles, was also the founder of the M.P. Moller Organ Works in the late 19th century. The company was the biggest pipe organ factory in the world during the first part of the 20th century. (Courtesy Washington County Historical Society.)

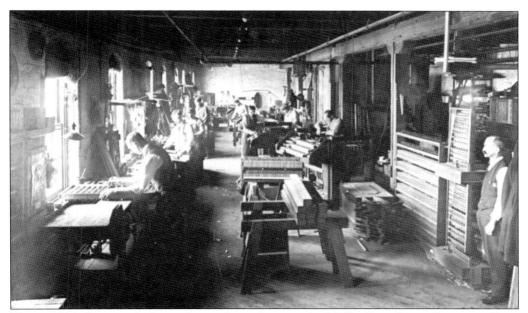

This c. 1914 photograph shows the inside workings at the Moller Pipe Organ Company. From 1880 to 1929, 5,600 organs were built by the company and shipped to many parts of the world. (Courtesy *Maryland Cracker Barrel*.)

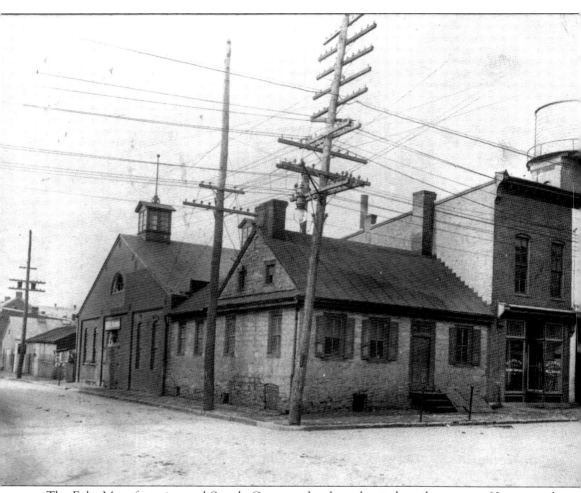

The Foltz Manufacturing and Supply Company has been located on the corner of Locust and Washington Streets since its beginnings in 1882. The old stone building pictured above was demolished in 1914 to build the larger building that stands on the site today. Though new industrial supplies are continually being added to the product line, tradition is still a way of life for the Foltz Company. In the 1970s, nearly 100 years after its founding, the old forge was still in use and the company still made metal stock troughs for feeding and watering livestock from the original patterns and castings. (Courtesy *Maryland Cracker Barrel*.)

Four

COMMERCE AND COMMUNITY SERVICE

The old Hagerstown Bank on West Washington Street is pictured here in 1929. Banking first came to Hagerstown in 1807 when Nathaniel Rochester (the founder of Rochester, New York) set up the first bank in his home and became its first president. The importance of the bank can be put in perspective by the fact that in 1810 there were only 103 banks in existence throughout the entire young country. In 1933 the bank was taken over by its successor, The Hagerstown Trust Company, and the building was torn down and later replaced by a Montgomery Ward department store. (Courtesy Washington County Historical Society.)

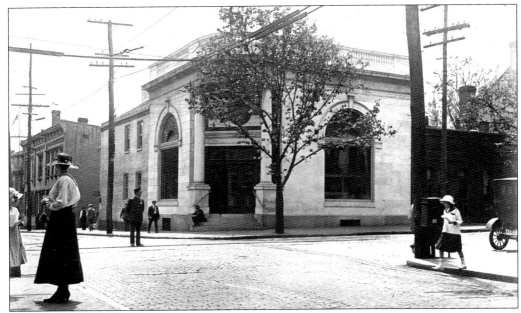

Taken on June 30, 1917, this photograph shows the corner of West Washington and Jonathan Streets. Note the style of the women's clothing. The Nicodemus Bank (now called Allfirst) sits on the same corner it occupies today, and a policeman stands in the center of the cobbled street to direct traffic (note the trolley tracks running in front of him). (Courtesy Washington County Historical Society.)

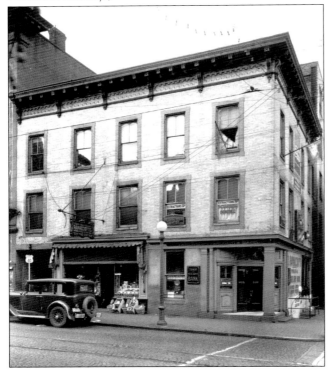

This 1920s view shows the Farmers and Merchants Bank on the corner of North Potomac and West Washington Streets. Ramacciotti's store is next door and a dentist's office is above, offering extractions for 30¢. Note the old sign for U.S. Route 40 near the car. (Courtesy Washington County Historical Society.)

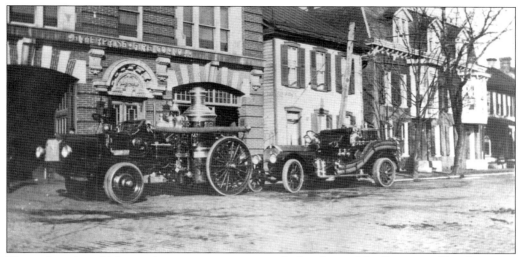

These gleaming old fire engines were quite a site parked in front of the Enterprise Fire Company Number 4 located at 526 Washington Square. Western Enterprise Fire Company was incorporated in 1872 and was located on this site in 1906. (Courtesy Washington County Historical Society.)

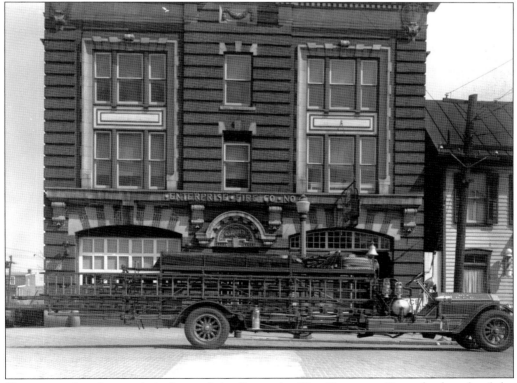

Here is another fire truck in front of the Enterprise Fire Company. Note the length of the ladders and of the truck itself. (Courtesy Washington County Historical Society.)

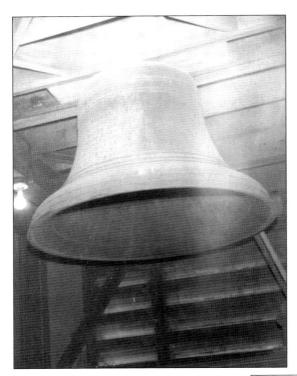

At one time, the fire alarm in Hagerstown had a distinctive pattern or "code" in the sound that would indicate where the fire was located. This photograph shows the fire alarm bell at the top of city hall on January 31, 1960. (Courtesy Western Maryland Room Washington County Free Library.)

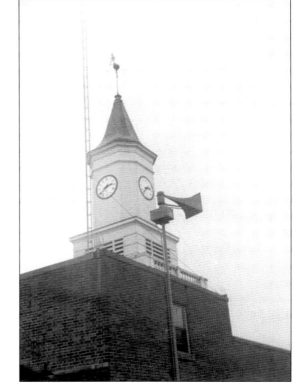

In this April 19, 1959 photograph not only can the town clock on the roof of city hall and Little Heiskell at his post be seen but also the town siren. (Courtesy Western Maryland Room, Washington County Free Library.)

In 1908 the Washington County Hospital was located in this house on the corner of Potomac Street and Fairground Avenue. The home was previously a residence of M.P. Moller, the owner of the Moller Pipe Organ Company. (Courtesy Washington County Historical Society.)

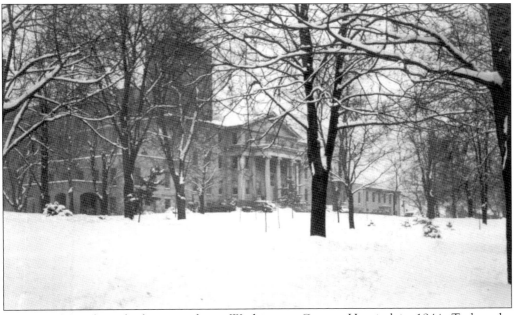

A snowy view through the trees shows Washington County Hospital in 1944. Today, the hospital has grown by leaps and bounds and has a helipad for the Maryland State Police Medivac helicopter. Operated in close conjunction with the hospital is the huge Robinwood Medical Center complex. Many doctors maintain offices here, patient labs for blood work are housed here, and the outpatient surgery center is kept very busy. (Courtesy Western Maryland Room, Washington County Free Library.)

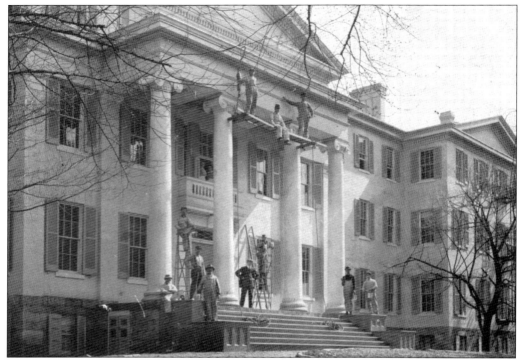

Kee-Mar College's history began in 1853 when it was known as the Hagerstown Female Seminary. It continued to operate as an exclusive women's school after its name was changed to Kee-Mar College in 1891. In the early weeks of the Civil War, the building was used as headquarters for the Union occupation of Hagerstown. The college closed in 1911; it was later turned into the Washington County Hospital and it has undergone many renovations since that time. (Courtesy *Maryland Cracker Barrel*.)

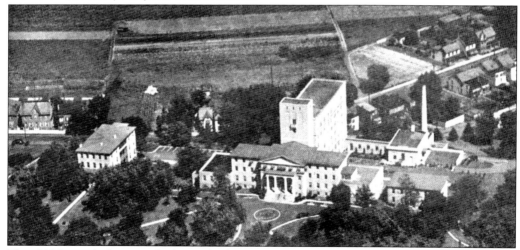

This 1939 aerial photograph shows the hospital after a large addition had been made in the back of the original Kee-Mar building. Also, the nurse's residence can be seen off to the left. Note the wide-open space in the area surrounding the hospital. Today, the hospital has been expanded again and the area is very built up. (Courtesy *Maryland Cracker Barrel*.)

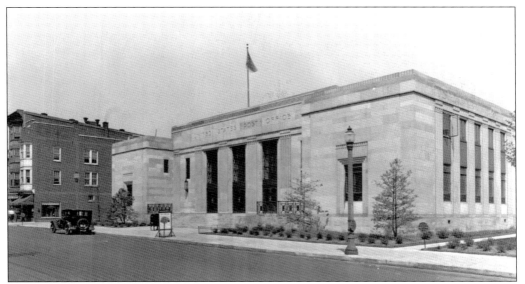

Previously located on Antietam Street in the building currently occupied by the Community Action Council, the Hagerstown Post Office later moved to this new structure built on Franklin Street in 1935–1937. The building was enlarged with the addition of a wing in 1963; this photo was taken in the late 1930s/early 1940s. (Courtesy Washington County Historical Society.)

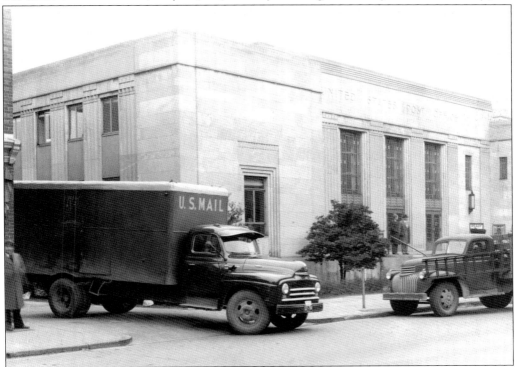

Here, an old U.S. Mail delivery truck heads out from the docks at the back of the Hagerstown Post Office on West Franklin Street. (Courtesy Western Maryland Room, Washington County Free Library.)

As on other buildings all around the country, the flag flew at half mast on the Hagerstown Post Office on Franklin Street in memory of Franklin D. Roosevelt on May 7, 1945. (Courtesy Western Maryland Room, Washington County Free Library.)

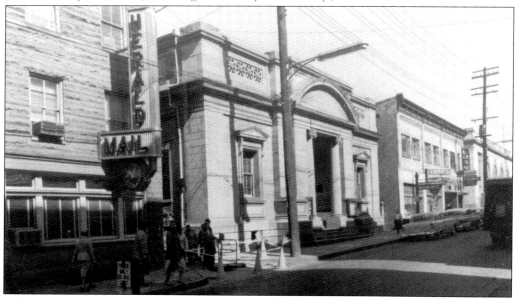

Taken in the mid-1900s, this photograph depicts two of Hagerstown's older buildings on Summit Avenue—the Herald-Mail building and, next door, the original Washington County Library. Prior to 1920, the *Morning Herald* and the *Daily Mail* were published as two completely different papers. Now, though they are still issued separately (the morning edition *Herald* and the evening edition *Mail*), they are under one owner and are united in one building. The building shown here was replaced in 1980 with a new structure down the street on the site where the B&O Railroad station once stood. The Washington County Free Library opened in 1901 and is the second oldest county library in the country. In 1965 the library moved to a new, much more spacious building on the corner of Antietam and South Potomac Streets. The old building is now used as offices. (Courtesy Washington County Historical Society.)

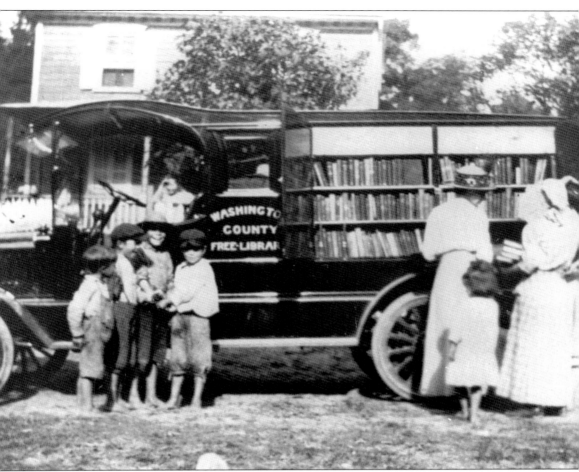

In 1904 the town librarian Mary Titcomb began the world's very first book wagon service when she began using the library wagon to send books to the rural residents of Washington County. The book wagon served as a model for libraries around the world. Service was discontinued during the Great Depression and then again during the gas rationing days of World War II. The original wagon was later replaced by a specially equipped truck that was ultimately replaced with the mammoth bookmobile of today, outfitted to serve the needs of modern patrons. (Courtesy Washington County Historical Society.)

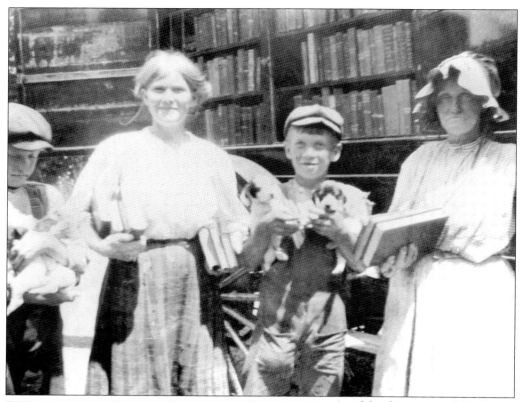

Armfuls of puppies and books bring smiles to these people after making their selections from the bookmobile in the early years of the 20th century. Originally, there were 16 book wagon routes laid out across the county but these were expanded in later years. (Courtesy Western Maryland Room, Washington County Free Library.)

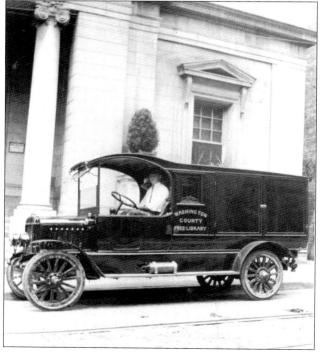

One of the early county bookmobiles is parked outside the old library building on Summit Avenue in this *c.* 1915 photograph. (Courtesy Western Maryland Room, Washington County Free Library.)

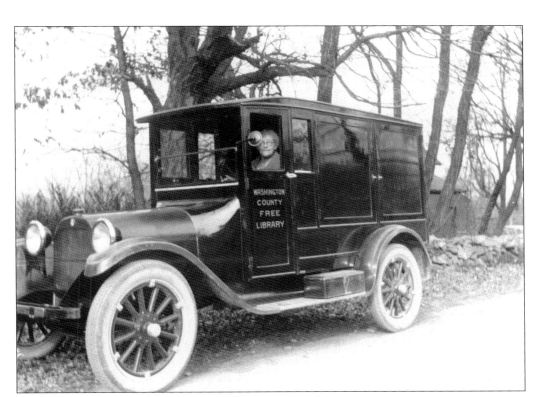

Here, another version of the bookmobile from the Washington County Free Library is out and about on the county's roads. The doors on the side of the wagon opened to display the books inside. The shelves could hold approximately 200 books. Later models held 300 books, and families were allowed to borrow up to 30 books on each visit. (Courtesy Western Maryland Room, Washington County Free Library.)

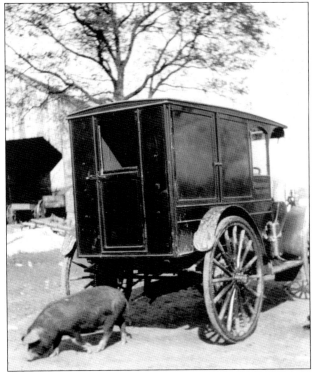

A local farm pig gets into the act snuffling along behind the parked bookmobile. Note the mud-splattered fenders offering evidence of the rough roads traveled while bringing books to the public. (Courtesy Western Maryland Room, Washington County Free Library.)

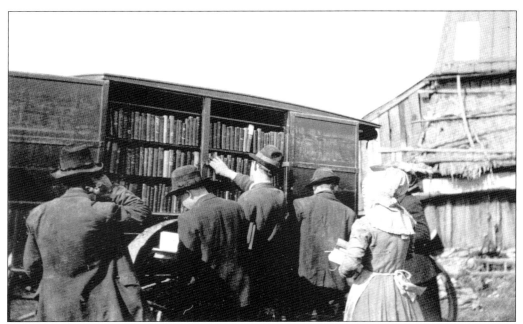

The whole neighborhood takes time out from the day's chores in this *c.* 1915 view to select books from the book wagon as it made its way around the county. (Courtesy Western Maryland Room, Washington County Free Library.)

This photograph shows the corner of Antietam and South Potomac Streets in 1961 prior to the construction of the new library. All of these buildings, including the Esso station and Central Motors, were torn down to build the county's new main library. (Courtesy Western Maryland Room, Washington County Free Library.)

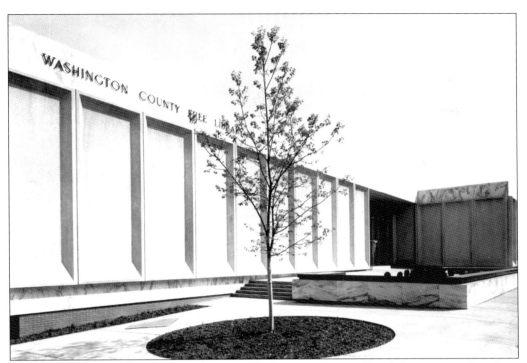

Seen here in 1980, the main branch of the Washington County Free Library opened on June 13, 1965 in its new modern home on the corner of Antietam and South Potomac Streets. (Courtesy Washington County Historical Society.)

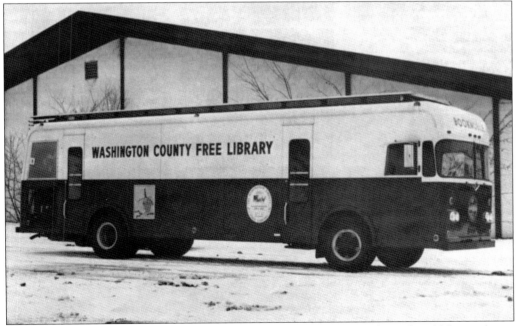

Here is a modern bookmobile from the library—quite a difference from the old horse-drawn carts and early motor vehicles! (Courtesy *Maryland Cracker Barrel*.)

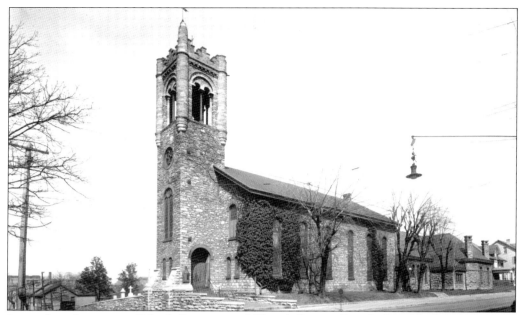

Located on the corner of North Potomac and Church Streets, Zion Reformed Church was built in 1774–1776. This German Reformed Church was the first large building in Hagerstown and seemed even more imposing due to its position on Potato Hill. Jonathan Hager donated the land and lumber used in the construction of the building. In a twist of fate, he was killed while working on site of the church in 1775. He, his wife, and his son are buried in the graveyard behind the church. (Courtesy Washington County Historical Society.)

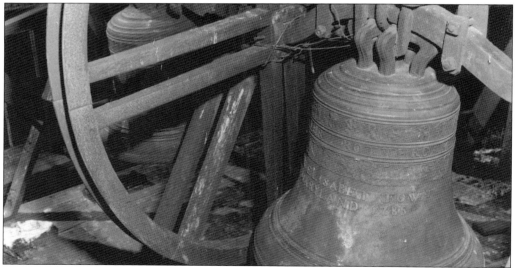

This 1952 photograph shows the bells in the tower of the Zion Reformed Church. The bells have the name "Elisabet Town" on them. because Hager originally named the town for his wife, Elizabeth. The local population always referred to it as "Hager's Town" and the name was formally changed in 1814. George Armstrong Custer (of Little Bighorn fame) used the bell tower during the Civil War as a lookout post. His cavalry brigade drove Confederate troops from town on July 12, 1863. (Courtesy Washington County Historical Society.)

St. John's Lutheran Congregation formed in Hagerstown in 1770, and pictured here is St. John's Evangelical Church on South Potomac Street. Originally housed in a log church, St. John's had the present-day Georgian-style building erected in 1795. The building underwent several renovations between 1870 and 1910. The tower was used as a lookout to observe Confederate troops during the Civil War. (Courtesy Washington County Historical Society.)

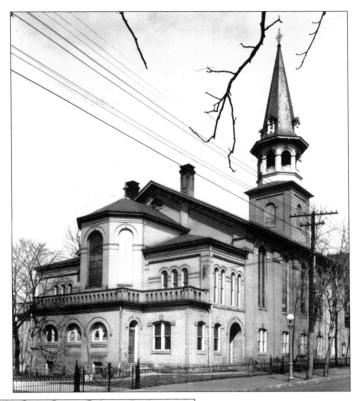

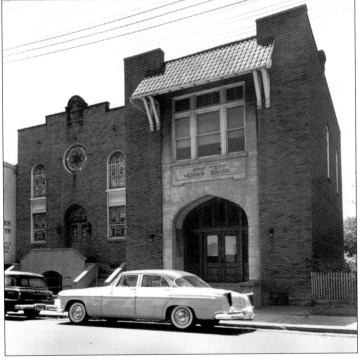

Jewish settlement in Western Maryland dates from 1762, and Hagerstown's Jewish community held services in the Presbyterian church until 1875. In 1895 a synagogue was built on Baltimore Street and the adjoining building was constructed in 1921. The present-day Congregation B'nai Abraham synagogue was built in 1923. (Courtesy Washington County Historical Society.)

The cornerstone laying ceremony at First Brethren Church, which was founded in 1894, was held on August 23, 1914. The late Gothic Revival-style church on Mulberry Street was dedicated in 1915. (Courtesy Washington County Historical Society.)

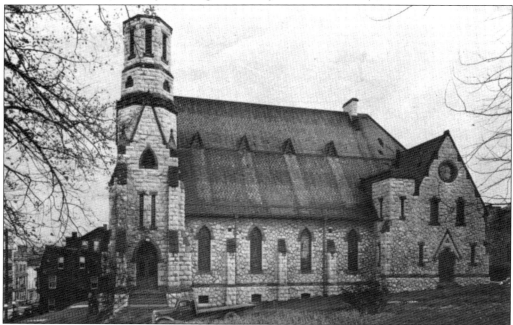

This photograph depicts the Presbyterian church on the corner of West Washington and South Prospect Streets in the early 1930s. This Gothic Revival structure is made of limestone and was built in 1873–1875. The grassy lawn in the foreground belonged to Mount Prospect, also known as the Rochester House. Today, a parking lot occupies this site across the street from the church. (Courtesy *Maryland Cracker Barrel*.)

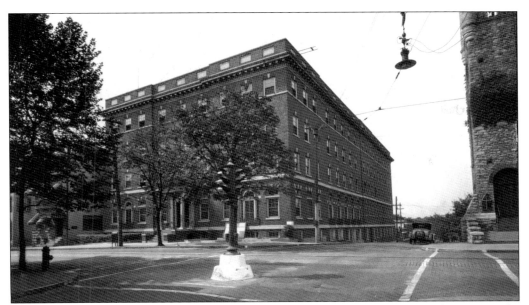

The Hagerstown YMCA is located at the corner of North Potomac and Church Streets. The cornerstone for the building was laid on October 1, 1920 and the official opening ceremony was held on May 1, 1922. The YMCA provides many programs for the community, such as swimming instruction, scouting programs, day camps, and more. Note the four-way traffic light in the street as well as the bell tower of the Zion Reformed Church on the right. (Courtesy Washington County Historical Society.)

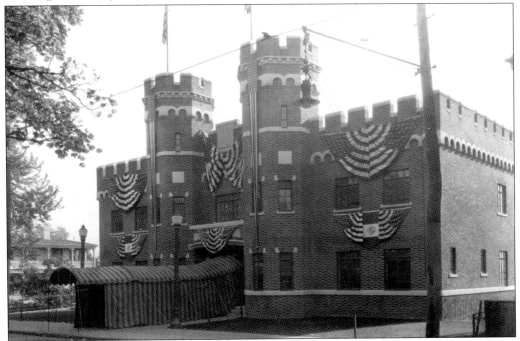

The Maryland National Guard Armory, seen above, is located on North Potomac Street. (Courtesy Western Maryland Room, Washington County Free Library.)

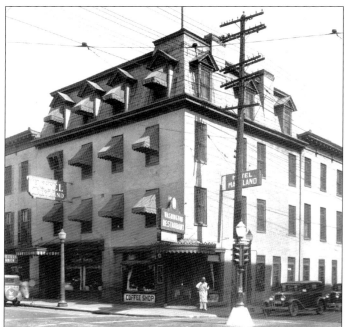

In 1926 the Hotel Maryland—with its Washington Restaurant and Coffee Shop—occupied the corner of West Washington and Jonathan Streets. The Western Union office can be seen just to the left of the hotel, and the B&O Railroad station was just one block up Summit Avenue. Note the traffic light in the center of the street serving all four sides of the intersection. (Courtesy Washington County Historical Society.)

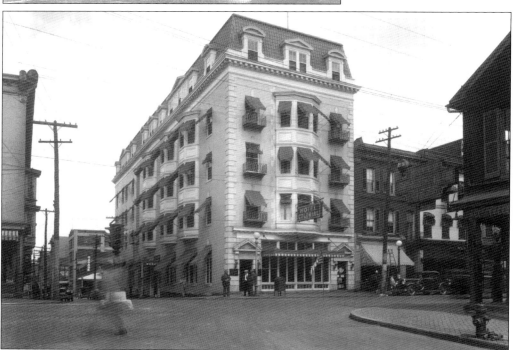

In 1926, the Colonial Hotel was located on the corner of South Potomac and Antietam Streets. Another of the large hotels in town supporting the rail traffic, the Colonial was just down the street from the B&O train station. In the right foreground stands an Amoco gas station with a large sign for Kelly Springfield tires. A German restaurant, Schmankerl Stube, occupies the gas station today. (Courtesy Washington County Historical Society.)

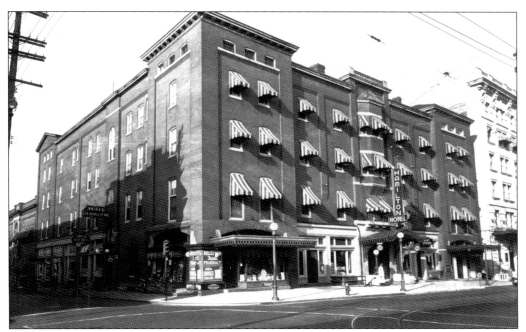

Located on the northeast corner of West Washington and Jonathan Streets, the Hamilton Hotel also provided rooms for weary travelers. The hotel was built in 1887 by William T. Hamilton, one of two Hagerstown men to serve as governor of Maryland. The building still stands today with the courthouse directly across the street on the southeast corner and the Nicodemus Bank standing cater-corner. (Courtesy Washington County Historical Society.)

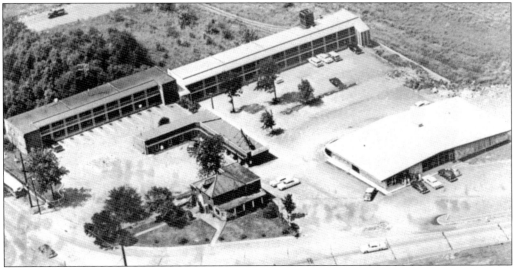

The Venice Inn had its beginnings in December 1949 in a small lunchroom added on to the Vidoni family home at the corner of Cleveland Avenue and the Dual Highway. The first 11-room motel unit was built behind the house in 1950, and 21 more rooms were added in 1951. In 1960, the family home was finally taken down to allow for further expansion. The house is still standing in this 1959 photograph that was taken after the new restaurant, lounge, and ballroom building on the right was constructed. (Courtesy *Maryland Cracker Barrel*.)

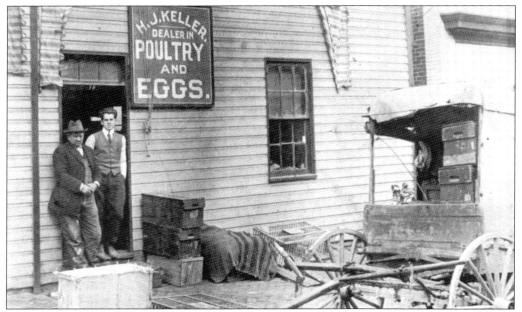

H.J. Keller's Poultry and Egg Store, seen in the early 1900s, was located on East Franklin Street, opposite city hall. Owner H.J. Keller is pictured along with one of his employees. Note the delivery wagon and crates for the poultry. (Courtesy Washington County Historical Society.)

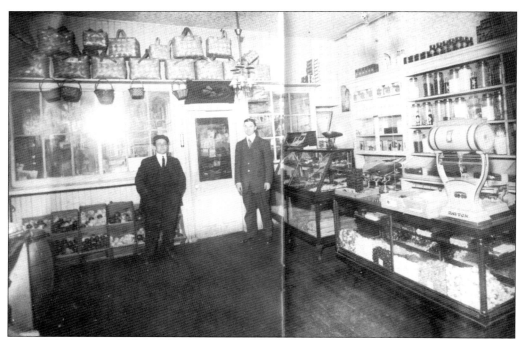

This 1910 photograph shows the interior of D. Ramacciotti's store, a landmark on the square for many years. Check out all the candy and fruit on display just waiting for a customer! (Courtesy *Maryland Cracker Barrel.*)

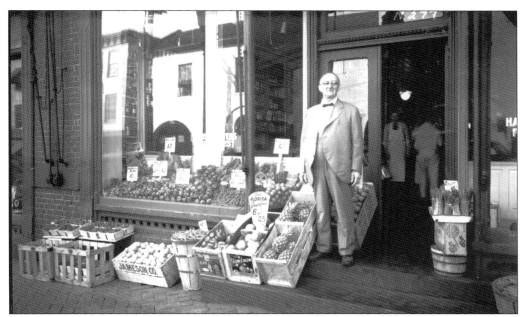

Harry S. Myers's grocery market was once located on the corner of North Potomac and West Franklin Streets. Six Florida grapefruit for 25¢ helps date this photo to days certainly long gone. (Courtesy Washington County Historical Society.)

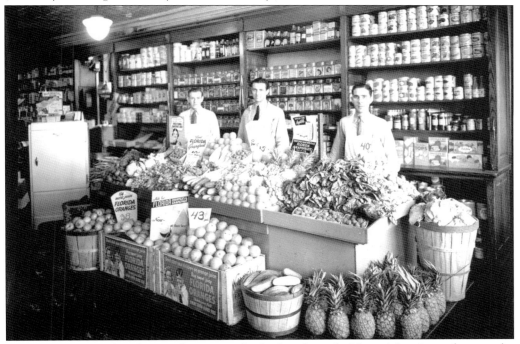

The produce was abundant and attractively displayed inside Harry Myers's market on the corner of North Potomac and Franklin Streets. Cucumbers, pineapples, grapefruit, oranges, and more are ready to be packed up for you by one of the store's assistants. (Courtesy Washington County Historical Society.)

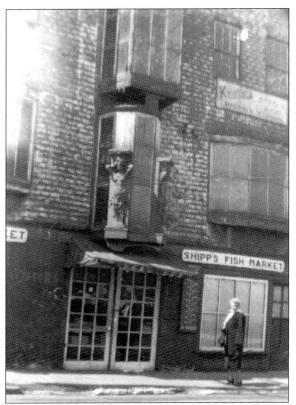

Taken in 1949, this photograph shows Shipp's Fish Market at 129 Summit Avenue. Knodle's Antique Shop occupied an upper level of the building. This store is reminiscent of the days before the large suburban supermarkets of today when shoppers visited specialty stores for fish, produce, and other needs. (Courtesy Washington County Historical Society.)

In this c. 1920 interior view of Shipp's Fish Market, there is a sawdust floor, a fresh fish bin on the right, and oyster tubs on the left. Roy Shipp opened his seafood market in 1916 on West Antietam Street and moved to this Summit Avenue location in 1919. Seafood had long been the family business—Roy worked with his father at their Jonathan Street store while his grandfather plied the streets of Hagerstown selling fresh fish from a horse and buggy. The shop on Summit Avenue closed in 1960. (Courtesy *Maryland Cracker Barrel.*)

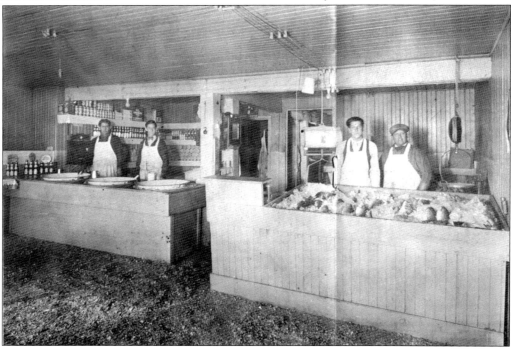

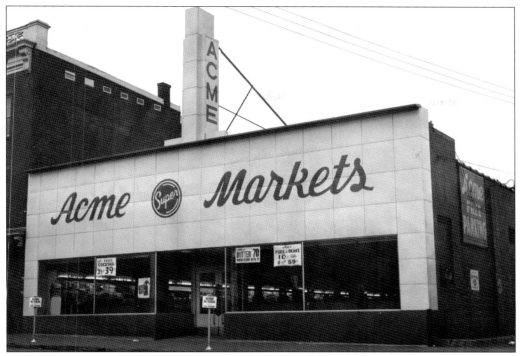

One of the main markets in town, Acme Market was located on Franklin Street in the heart of downtown Hagerstown. All of the large downtown markets are gone now; the Grand Union on the corner of Baltimore Street and Summit Avenue was one of the last to go. (Courtesy Washington County Historical Society.)

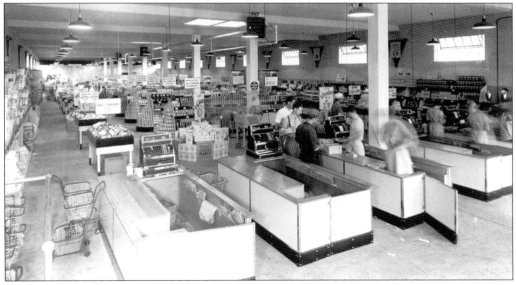

Pictured here is the interior of the Acme Market on Franklin Street. There are no conveyor belts on which to unload your cart or self-service scan stations in those days! Note the small size of the self-service carts parked on the left ready for customers to use. (Courtesy Washington County Historical Society.)

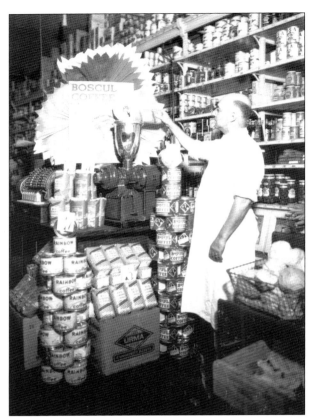

This is the interior of another one of downtown's grocery stores, Abe Martin's store, with its extensive display of coffee around the coffee grinder. Produce is on display to the right and the old-fashioned cash register is on the left. (Courtesy Washington County Historical Society.)

It was a busy Saturday morning at the City Market when this photograph was taken on May 7, 1955. Located downtown in a building behind the YMCA building, the market, founded in 1791 and the oldest active city market in Maryland, is still an early Saturday morning tradition. Fresh produce, meats, home-baked goods, flowers, craft items, and more are all available for sale at vendor stalls. (Courtesy Western Maryland Room, Washington County Free Library.)

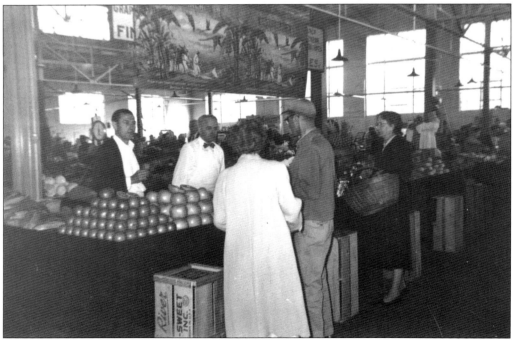

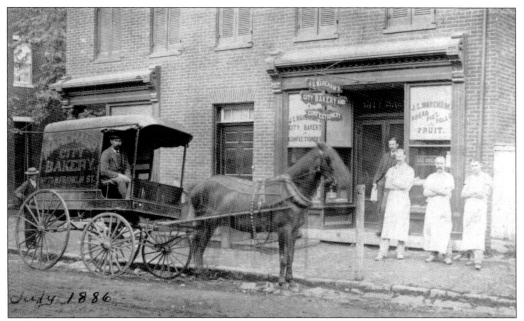

In this July 1886 view of Wareham's City Bakery at 75 West Franklin Street, workers are shown in front of the store. The delivery wagon is a typical example of the wagons used by businesses throughout town during this time period. The store sold bread, pies, and rolls as well as candies, ice cream, and fruit. (Courtesy Washington County Historical Society.)

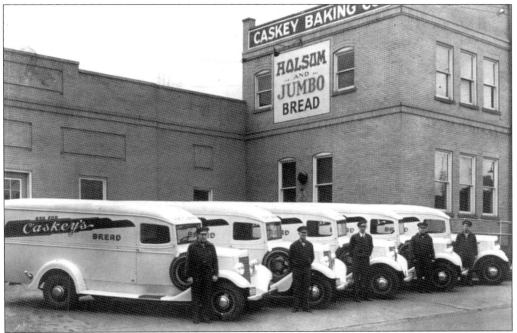

The Caskey Baking Company was located at 339 West Antietam Street. Taken in 1935, this photograph shows the drivers proudly lined up with their delivery trucks. (Courtesy Washington County Historical Society.)

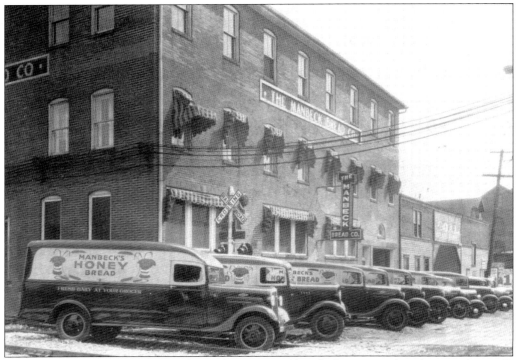

The Manbeck Bread Company, located on West Church Street, produced more than 150 varieties of bread during its almost 53 years of operation. The company had its own siding along the Western Maryland Railroad and flour was taken via a chute directly from the cars to the basement. This 1936 photograph shows the company's fleet of Chevrolet delivery vans. Trucks delivered the bakery's goods throughout Maryland, Pennsylvania, Virginia, West Virginia, and even New Jersey. (Courtesy *Maryland Cracker Barrel*.)

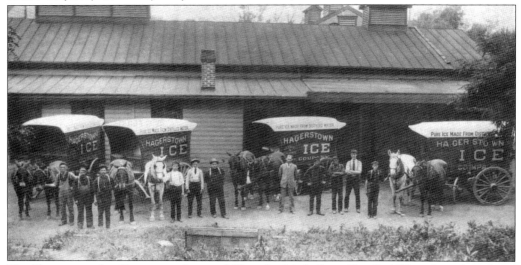

The Hagerstown Ice Company advertised "Pure Ice Made From Distilled Water" on the sides of their horse-drawn delivery wagons. This photograph of the company's employees at South Walnut and Prospect Street was taken in 1890. (Courtesy *Maryland Cracker Barrel*.)

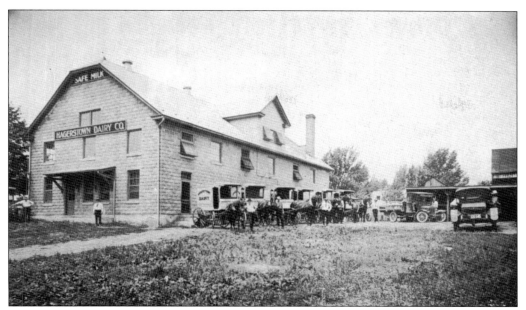

Hagerstown Dairy Company was located on South Potomac Street in the early 1900s. While a few motor vehicles can be seen in this view, most deliveries were still made throughout town the old horse-and-cart way. (Courtesy *Maryland Cracker Barrel*.)

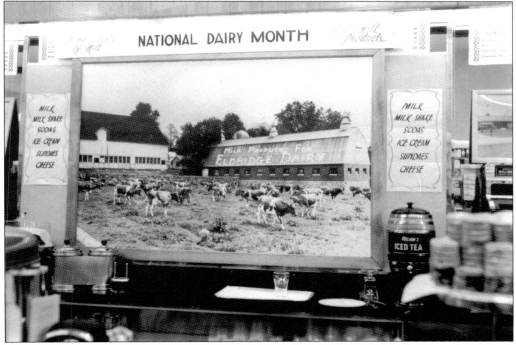

The cows of the Eldridge Dairy Company, located at 215 West Washington Street, are highlighted in the National Dairy Month display at People's Drug Store lunch counter. Milk bottles of various sizes from the Eldridge and Hagerstown Dairies can still be found today for sale in local antique and flea markets. (Courtesy Washington County Historical Society.)

This photograph shows the interior of Eakle's Drug Store at 42 West Washington Street. The store not only dispensed pharmaceuticals but also candy, hats, and other items. Note the soda fountain in the rear of the store. Eakle's is still in business today with locations on Pennsylvania Avenue and Burhans Boulevard. (Courtesy Washington County Historical Society.)

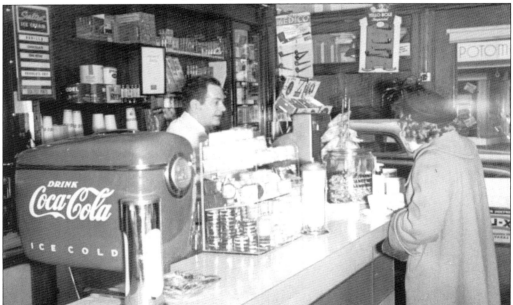

Another downtown drugstore was Middlekauff's at 31 North Potomac Street. This March 9, 1952 photograph shows just a few of the items to be had at the store, including ice cream and Coca-Cola. (Courtesy Western Maryland Room, Washington County Free Library.)

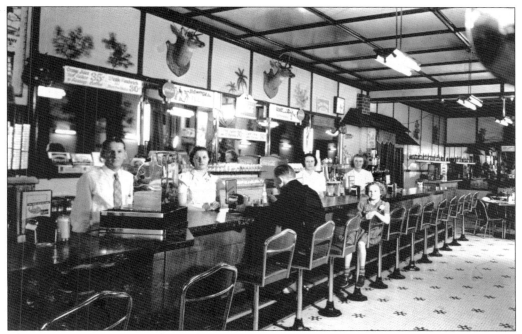

The Savoy Restaurant was located at 100 West Washington Street, and this *c.* 1937 image shows the interior of the restaurant. For 30¢, customers could order oyster stew or a steak sandwich. (Courtesy Washington County Historical Society.)

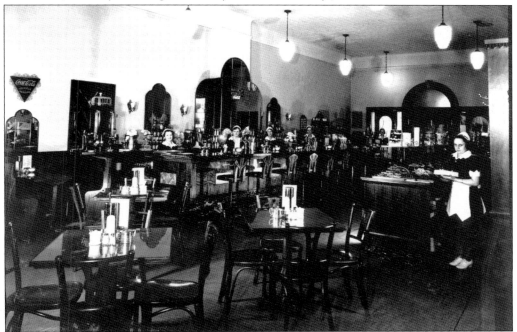

Another well-known downtown restaurant was the Lovely Dame on West Washington Street. Here, some of the waitresses inside the restaurant appear ready to serve their customers at shiny tables. (Courtesy Washington County Historical Society.)

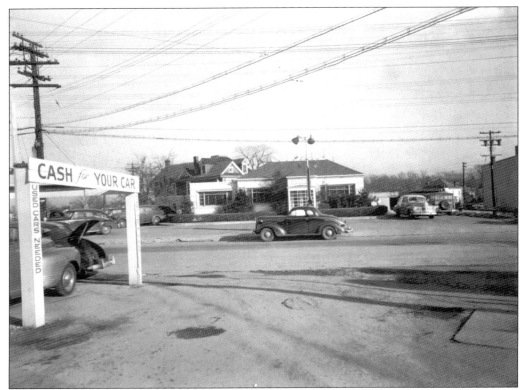

The rooftop lettering on this photograph lets us know that this is the Cheerio Drive-In Restaurant located on Pennsylvania Avenue near Park Lane in the 1940s. Across the street from the second Fairchild plant, the restaurant was open 24 hours a day with curb service from 4 p.m. to 1 a.m. Signs also proclaimed that the restaurant was air-conditioned and served Sealtest Ice Cream. (Courtesy Western Maryland Room, Washington County Free Library.)

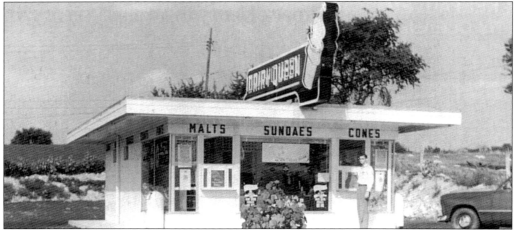

Dairy Queen opened on Dual Highway (U.S. Route 40) on May 29, 1952. At that time, Towson and Salisbury were the only other Maryland towns to have a similar ice cream establishment. The popular stand is still on the same site today and still pulls customers in right off the road. (Courtesy *Maryland Cracker Barrel*.)

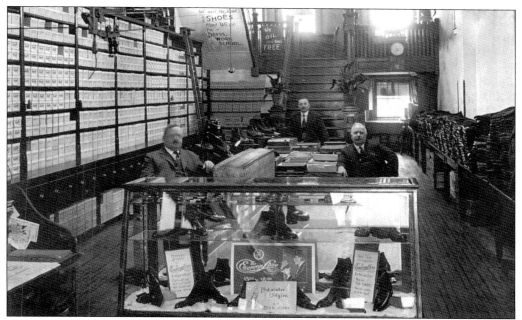

Seen here is the interior of the Brewer and Myers Clothing store in downtown Hagerstown. The Emerson shoes on display in the glass cabinet sold for anywhere from $3.50 to $8. The sign on the back wall reads, "We oil your shoes free." In those days, an attentive store assistant served customers and met all their needs. (Courtesy Washington County Historical Society.)

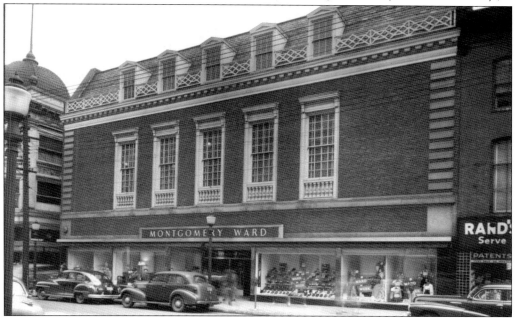

The Montgomery Ward store was first located downtown on Washington Street; the store would later move to the Valley Mall on Halfway Boulevard. Montgomery Ward has now closed its doors forever but will long be remembered as a staple in Hagerstown. (Courtesy Western Maryland Room, Washington County Free Library.)

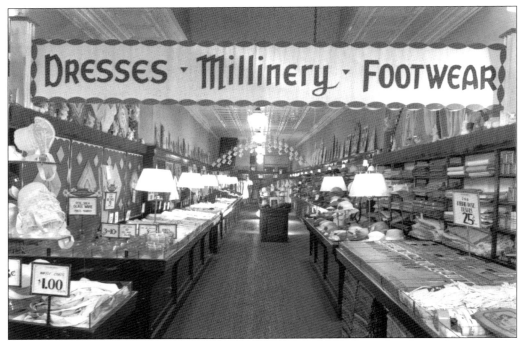

Newberry's five-and-ten was a downtown staple, and this interior snapshot shows the neat aisles of merchandise waiting for customers. (Courtesy Washington County Historical Society.)

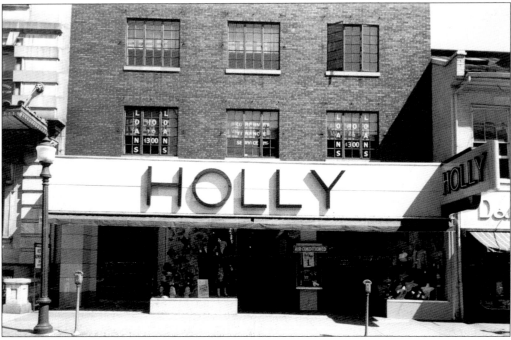

The Holly Department Store at 74 West Washington Street was an air-conditioned establishment that catered to women's needs and was a popular shopping spot. (Courtesy Western Maryland Room, Washington County Free Library.)

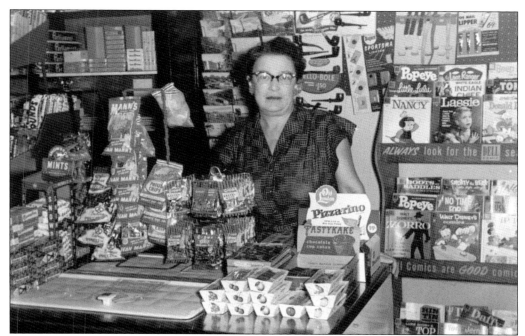

Candy, pipes, magazines, and more were all to be found inside the Hagerstown News Agency at 45 North Potomac Street on July 23, 1958. Note the Tastycake fruit pies on the counter—those same pies in the fruit-decorated boxes are still recognizable on grocery store shelves today. (Courtesy Western Maryland Room, Washington County Free Library.)

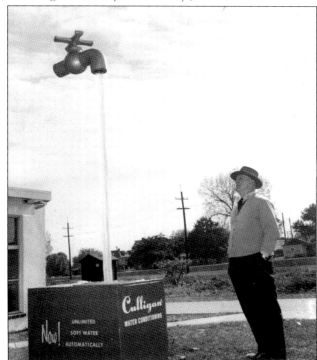

The water faucet in the sky was as puzzling then as now, and this man tries to figure out "how did they do that?" outside Culligan's Soft Water Service on Summit Avenue on October 22, 1958. (Courtesy Western Maryland Room, Washington County Free Library.)

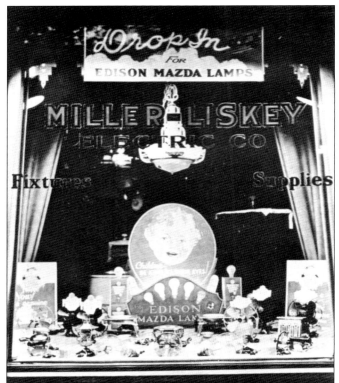

The Miller-Liskey Electric Company was founded in 1927 and opened this shop on East Franklin Street. The company combined an electrical retail store with a motor and construction shop. As this window advertisement shows, the company sold Edison Mazda Lamps that were being promoted as healthy for children. (Courtesy *Maryland Cracker Barrel.*)

In 1959 the retail part of the Miller-Liskey business was sold, and the motor repair/construction portion of the business was moved to a new shop on East Antietam Street. It was later moved to Lee Street. (Courtesy *Maryland Cracker Barrel.*)

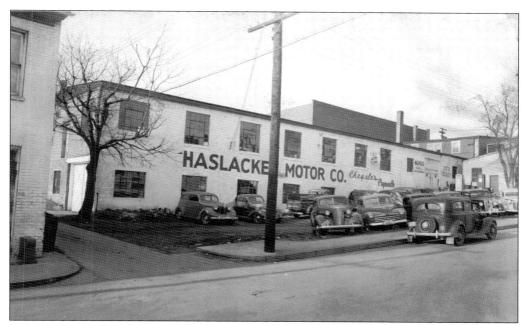

In 1949 the Haslacker Motor Company was located downtown at 55 East Baltimore Street. New Chrysler and Plymouth cars are lined up waiting for a buyer. (Courtesy Western Maryland Room, Washington County Free Library.)

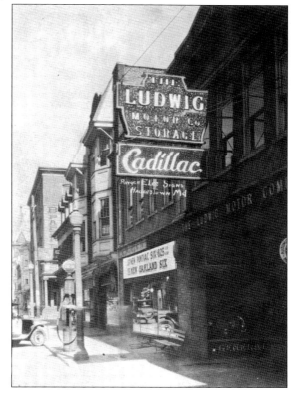

The Ludwig Motor Company was located on West Franklin Street in the early 1920s. The sign on the showroom window proclaims that a new Pontiac cost the grand sum of $825! Today, the Hagerstown Post Office stands on this site. (Courtesy *Maryland Cracker Barrel.*)

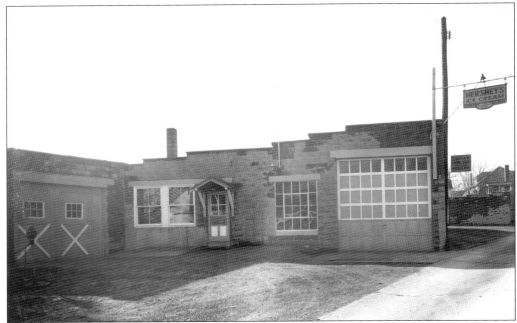

Hershey's Ice Cream is found in grocery and convenience stores throughout the region. Here, the Hershey Creamery Company's sign proudly proclaims the name of the well-loved treat produced there. (Courtesy Western Maryland Room, Washington County Free Library.)

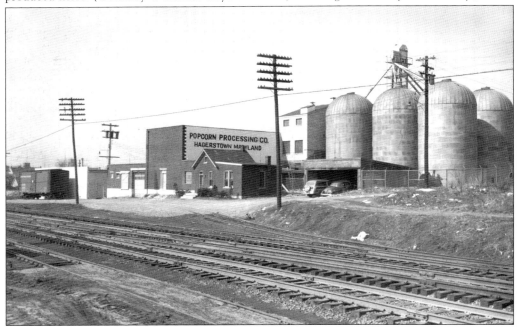

This c. 1950 photograph shows that Hagerstown was once home to the Popcorn Processing Company. Lee Stine owned the popcorn silos shown here. Note the railroad track leading from the main lines to a siding near the plant. (Courtesy Western Maryland Room, Washington County Free Library.)

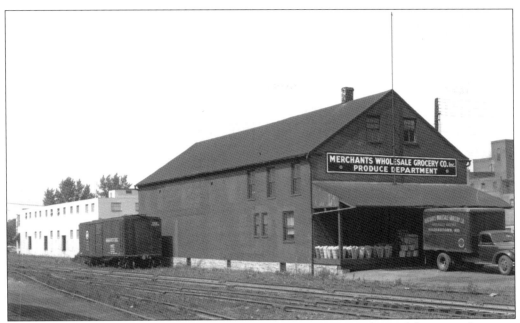

In the late 1940s Merchants Wholesale Grocery Company was located here on the main Pennsylvania Railroad lines between West Church and West Franklin Streets. (Courtesy Western Maryland Room, Washington County Free Library.)

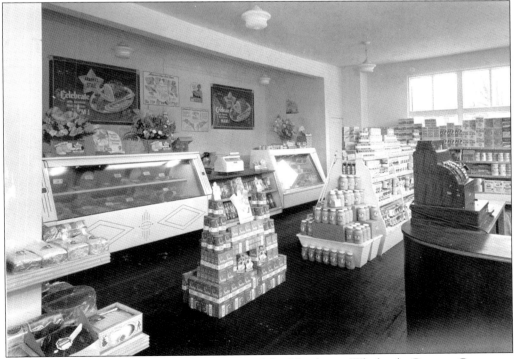

Another late 1940s image shows the interior of the Merchants Wholesale Grocery Company. (Courtesy Western Maryland Room, Washington County Free Library.)

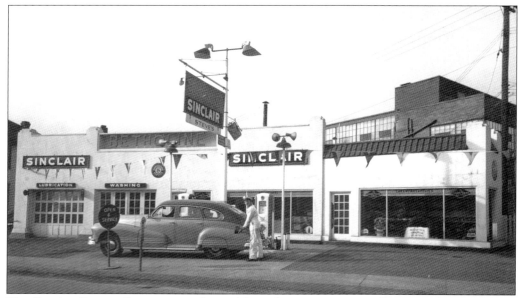

This Sinclair Service Station reminds us of days when a car was actually serviced at the service station. Here, the uniformed attendant pumps gas while the customer waits in the car. While no longer in Hagerstown, Sinclair gas stations can still be found under the sign of the green dinosaur in other areas of the country. (Courtesy Western Maryland Room, Washington County Free Library.)

Taken c. 1937, this photograph shows Miller's garage at the intersection of Sharpsburg Pike and Downsville. The vintage gas pumps were selling six gallons of gas for $1.05! Signs on the right give the directions and distances for various locations. The Elks club is on the right, and Downsville and Dam No. 4 are also on the right along the state route. To the left are the Potomac Ferry; Shepherdstown and Charles Town, West Virginia; and Berryville, Virginia. There is also a sign pointing to the left for the Maryland State Penal Farm, just five miles away. (Courtesy Washington County Historical Society.)

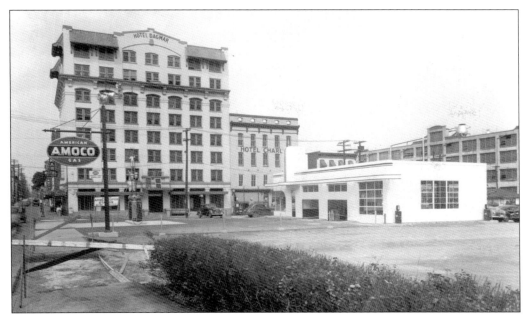

This Amoco Station (American Oil Company) was located on the corner of Summit Avenue and Antietam Street where the B&O Railroad station once stood. The Dagmar Hotel can be seen across the street with the Charles Hotel next door. The Dagmar was named for the daughter of M.P. Moller, the founder of the M.P. Moller Organ Works as well as the M.P. Moller Motor Car Company. The hotel was one of the most prestigious in the city and had light, airy rooms as well as hot and cold running water and long-distance phones in each room. (Courtesy Western Maryland Room, Washington County Free Library.)

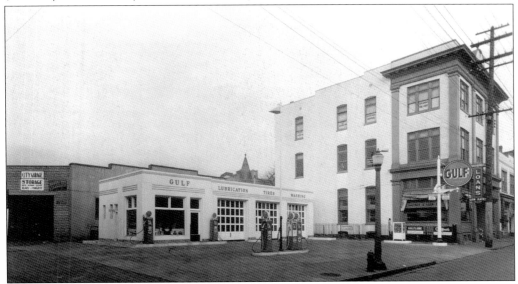

Another one of the service stations located in Hagerstown in the 1920s, the Gulf Station on North Jonathan Street not only offered gas but lube, tire, and car washing services. The City Garage is on the left and the Thomas Building (with the Central Chemical Corporation on the first floor) is on the right. (Courtesy Washington County Historical Society.)

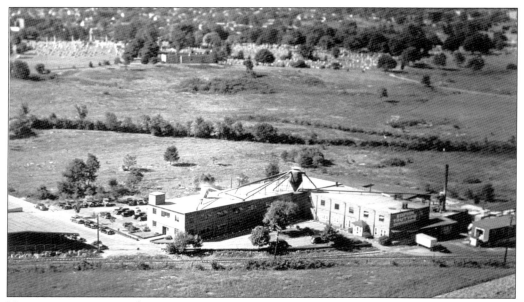

Hagerstown was once home to many thriving manufacturing operations including those making furniture, aircraft, refrigeration units, and much more. This aerial view shows the Statton Furniture Company located on First Street in the south end of town. Statton is still in business today and is one of the area's top 30 employers. (Courtesy Washington County Historical Society.)

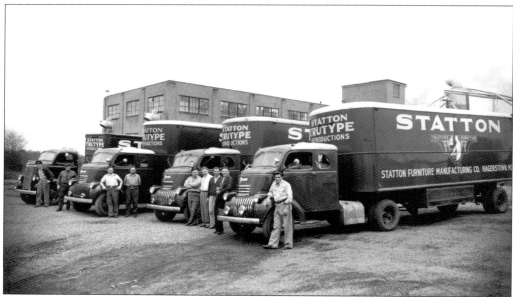

These delivery trucks parked outside the manufacturing plant proclaim that Statton Manufacturing Company produced Trutype Reproduction furniture. Founded in 1926, the company was a Fairchild subcontractor during World War II. After the war, the business began specializing in solid cherry copies of Chippendale, Hepplewhite, and Sheraton antiques. Today, Maidstone, Inc. on Summit Avenue is the exclusive Statton furniture dealer for Western Maryland. (Courtesy Western Maryland Room, Washington County Free Library.)

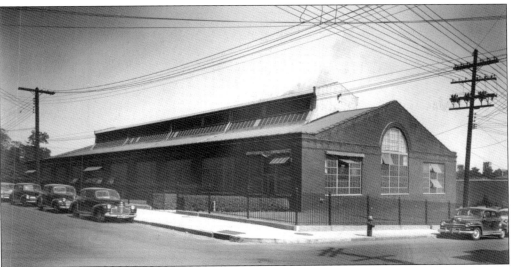

This building still stands today on North Prospect Street across the street from Goodwill Industries. At the time of this 1940s photograph, the Interwoven Silk Mill occupied the building. (Courtesy Western Maryland Room, Washington County Free Library.)

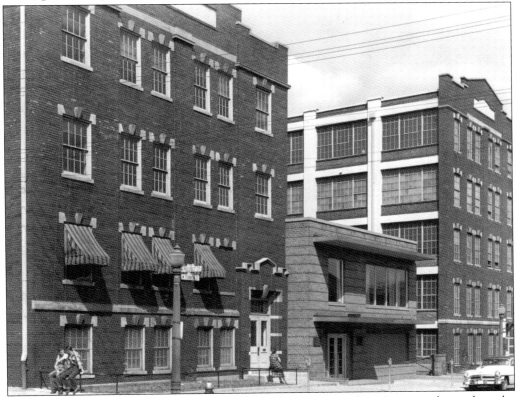

Another of Hagerstown's many industries was the Hagerstown Shoe Company located on the corner of North Prospect and West Franklin Streets. (Courtesy Western Maryland Room, Washington County Free Library.)

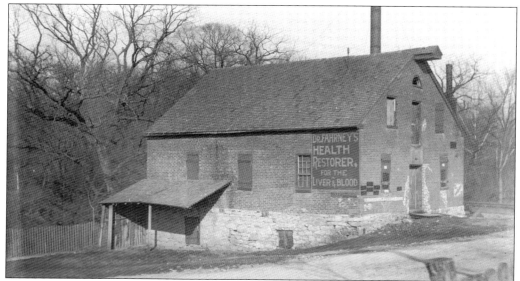

In 1897 this gristmill was located along Virginia Avenue at the current entrance to the Hagerstown City Park. Note the advertising on the side of the building for Dr. Fahrney's Health Restorers for the liver and blood. You would likely find Dr. Fahrney's potions in stores downtown. (Courtesy Washington County Historical Society.)

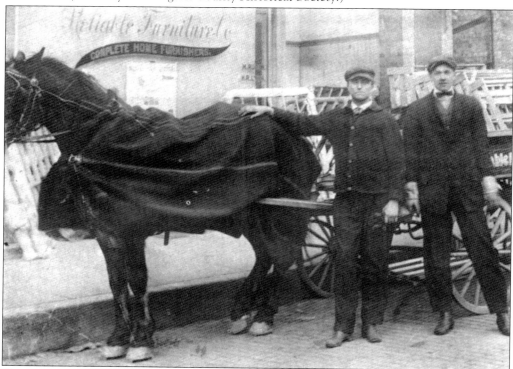

This 1910 photograph shows the Reliable Furniture Company located on West Franklin Street. The horse-drawn wagon stood ready to deliver furnishings to their new homes. (Courtesy *Maryland Cracker Barrel.*)

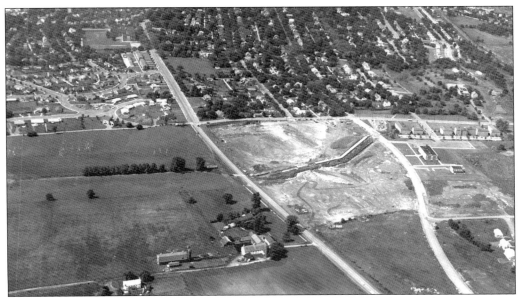

This aerial view captured on June 15, 1957 shows construction work about to begin on a new shopping center on Northern Avenue. This shopping center would be known as Long Meadow Shopping Center; it still stands today with some of its original signage. (Courtesy Western Maryland Room, Washington County Free Library.)

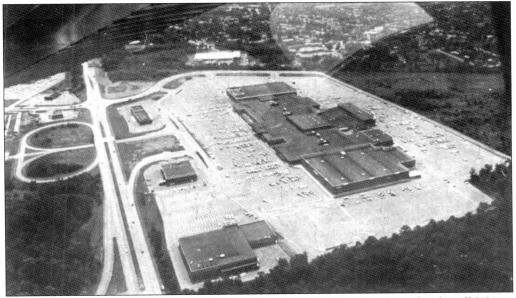

In another aerial photograph the Valley Mall, built on Halfway Boulevard right off I-81, is visible. In the early days, the mall had three anchor stores—Montgomery Ward, JC Penney, and Eyerly's. Ward had a thriving catalog business as well as a cafeteria and deli counter. Now, Montgomery Ward is gone and Sears is expected to move from the Long Meadow Shopping Center to take its place. The mall has also expanded and now houses Hecht's, a food court, a large movie theater, and a new wing of stores. More stores have been built behind the mall as well as across Halfway Boulevard. (Courtesy *Maryland Cracker Barrel*.)

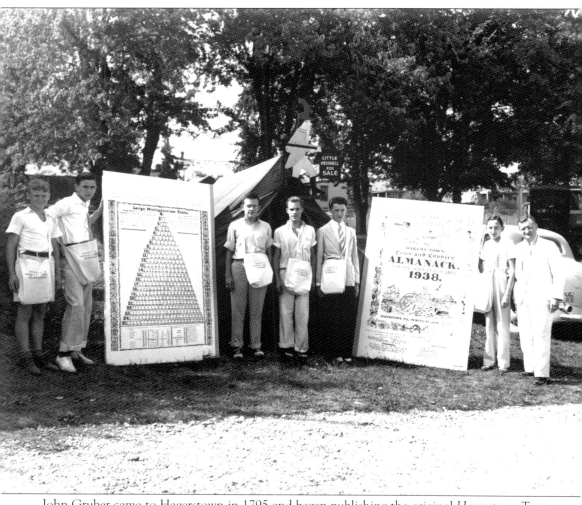

John Gruber came to Hagerstown in 1795 and began publishing the original *Hagerstown Town and Country Almanack* in 1797. It has been published every year since. Gruber lived in a house on South Potomac Street where the Maryland Theater now stands and his front room was used as his printing shop. The almanac is well respected throughout the entire region, from Pennsylvania to Virginia, West Virginia to Ohio, and its weather prognostications have been on the money on a regular basis, following an old formula of calculation. Additionally, an annual "wooly bear contest" is held by the almanac in conjunction with the local newspaper. These small multi-color banded caterpillars have long been thought to predict the severity of the winter based on the size of their bands of color. There is a search for the popular weather-predicting caterpillars each year, and they are entered in a contest for the "largest" and "woolliest," among other categories. (Courtesy Washington County Historical Society.)

Five

ENTERTAINMENT
AND LEISURE

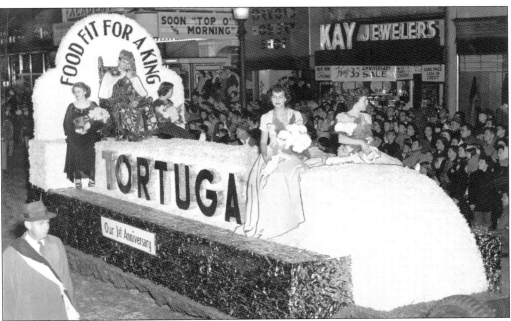

Beginning in 1921, the Alsatia Mummer's Parade has been held every year at Halloween (with the exception of three years during World War II). The parade is one of the largest on the East Coast and attracts participants and spectators from far and wide. Here, a 1949 parade float, celebrating the one-year anniversary of the well-known local Tortuga restaurant, winds its way along the parade route. Note that at the time of this photograph the parade route followed West Washington Street instead of the current route down Potomac Street. (Courtesy Washington County Historical Society.)

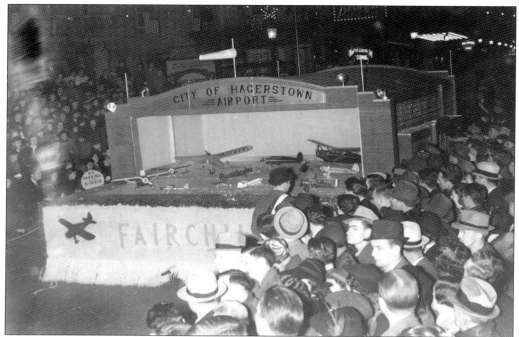

Note the crowds along the street watching the Alsatia Mummer's Parade. The float that has just come into view was built by Fairchild and depicts the new hangar at the City of Hagerstown Airport. (Courtesy Washington County Historical Society.)

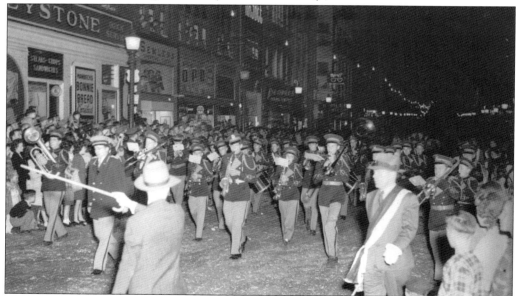

The members of the Hagerstown High School band march down the street during this October 21, 1946 Mummer's Parade. Some of the stores in the background are May's Optical, People's Drug Store, Kohler Jeweler's, and Manbeck's Bread. A number of people looked out on the parade from the windows of Semler's Sporting Goods Store. (Courtesy Western Maryland Room Washington County Free Library.)

On November 1, 1948 a kangaroo balloon—complete with a joey in her pouch—proceeds down the Mummer's Parade route. Leiter Brother's store, Kay Jewelers, and the Academy Theater are visible in the background. (Courtesy Western Maryland Room, Washington County Free Library.)

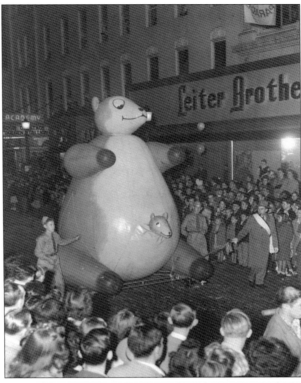

Another November 1, 1948 Mummer's Parade float entry was this one from Anderson Company Cleaners. The company was located on East Washington Street, and for many years, the old polar bears in the front window advertising the company's cold storage were a well-known sight along the street. Here, a polar bear rides in splendor on the float. (Courtesy Western Maryland Room Washington County Free Library.)

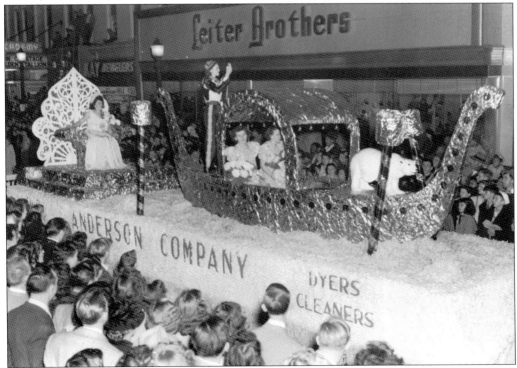

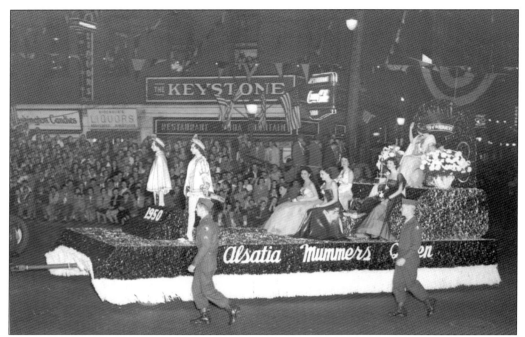

The Alsatia Mummer's Parade queen and her court ride on this float in 1950. The float is just making a right turn onto South Potomac Street from West Washington. (Courtesy Western Maryland Room, Washington County Free Library.)

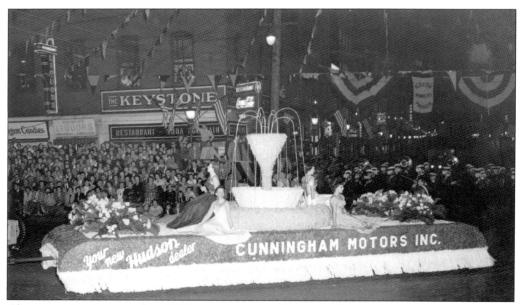

Also participating in the 1950 parade, this float for Cunningham Motors advertises new Hudsons. Behind the crowd of people are a liquor store, Washington Candies, and the Keystone Restaurant and Soda Fountain. (Courtesy Western Maryland Room, Washington County Free Library.)

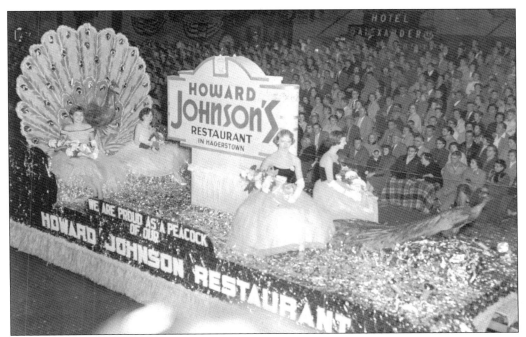

This float was entered in the October 29, 1955 Mummer's parade. Howard Johnson's hotel is now the Plaza Hotel near the Valley Mall and the restaurant is called the Fireside. (Courtesy Western Maryland Room, Washington County Free Library.)

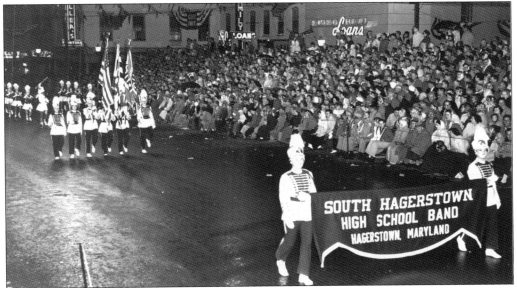

Quite a crowd attended the November 1, 1958 Alsatia Mummer's Parade. Miller's Furniture and Household Finance Loans are in the background on the corner of West Washington and North Potomac Streets. Here, South Hagerstown High School comes down the street. The two Hagerstown high schools, North and South, take turns each year alternately leading and bringing up the rear of the parade. (Courtesy Western Maryland Room, Washington County Free Library.)

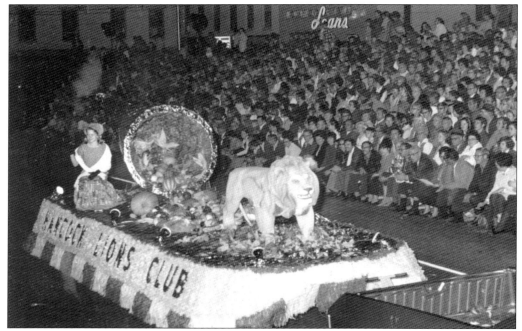

Service organizations are found throughout Hagerstown, the Lions and the Optimists, the Exchange Club and others. Here, the Hancock Lions Club float makes its way down the Alsatia Mummer's route in 1971. (Courtesy Western Maryland Room, Washington County Free Library.)

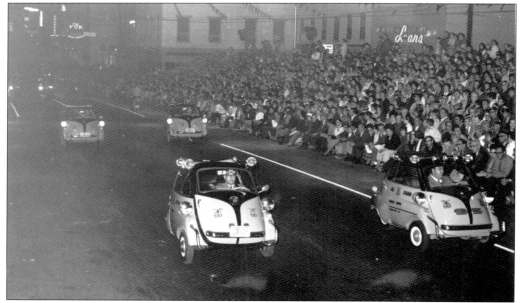

It was dark enough for these Shriner's to use the headlights on their little cars during this 1971 parade. The Ali Ghan Shriner's, who support Shriner's hospitals, are still part of the parade today, and members of their various groups ride on motorcycles and in small cars. (Courtesy Western Maryland Room, Washington County Free Library.)

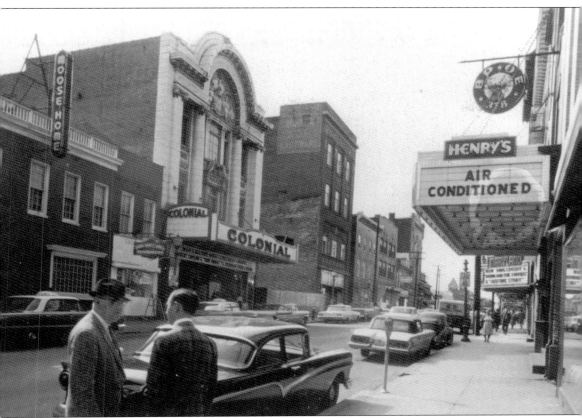

In the heyday of downtown, Hagerstown was served by not one but four theaters, all within a few blocks of each other. This photograph shows the Colonial, Henry's, and the Maryland Theaters on South Potomac Street. The Academy was located around the corner on West Washington Street. This photograph was taken prior to the 1974 fire at the Maryland Theater since it shows the theater coming right up to the sidewalk. The entrance and lobby were destroyed in the fire and were never reconstructed. Of the four theaters, the Maryland, built in 1915, is the only one still in use today. (Courtesy Washington County Historical Society.)

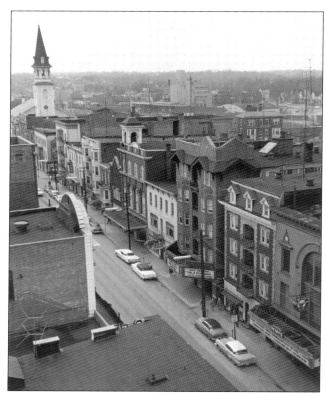

In this 1960s aerial view the rounded top of the Colonial Theater is visible on the left as well as Henry's and the Maryland Theaters on the right. Other Hagerstown buildings spread out in the background. The rounded dome just visible in the background was the Grand Union grocery store. (Courtesy Western Maryland Room, Washington County Free Library.)

The original Maryland Theater building on South Potomac Street came right up to the sidewalk in line with the other buildings on the street. This photograph shows the interior of the theater lobby in the years prior to the fire that destroyed the entire front of the building in 1975. (Courtesy Washington County Historical Society.)

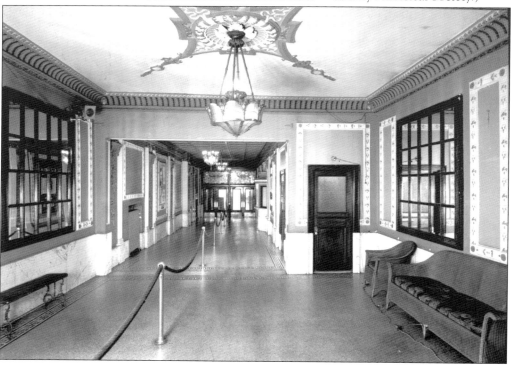

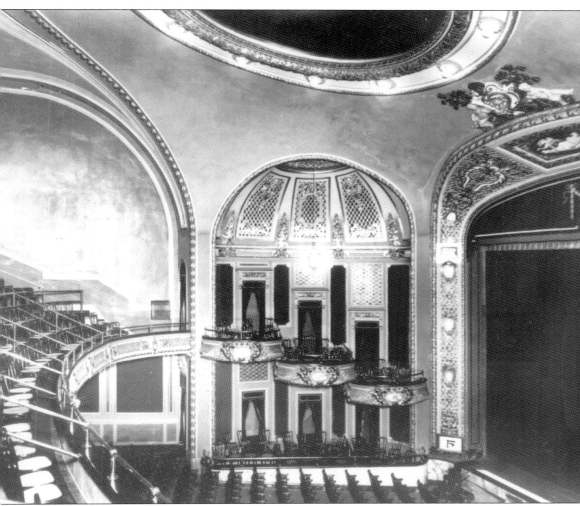

Again, here is the lavish interior of the Maryland Theater. Opened in 1915, the theater was designed in the late Italian baroque style by the famous theater architect Thomas W. Lamb. In 1976 a non-profit group was formed in Hagerstown to raise funds to buy and restore the theater. Today, the theater is an important part of cultural life in Hagerstown, hosting concerts, Broadway musicals, plays, and ballets. (Courtesy Western Maryland Room, Washington County Free Library.)

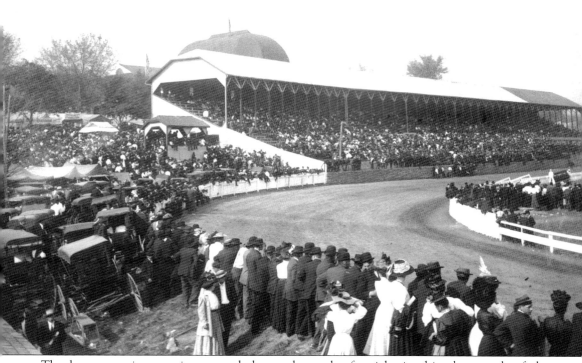

The horses are just coming around the track on the far right in this photograph of the grandstand and racetrack at the Great Hagerstown Fair, *c.* 1900. The first Hagerstown Fair was held in 1854 at a spot along the Williamsport Pike (Virginia Avenue). The fair moved to the fairgrounds located between Mulberry and Cleveland Avenues in 1880. This grandstand would later be replaced by the concrete and steel structure that is on the site today. (Courtesy Washington County Historical Society.)

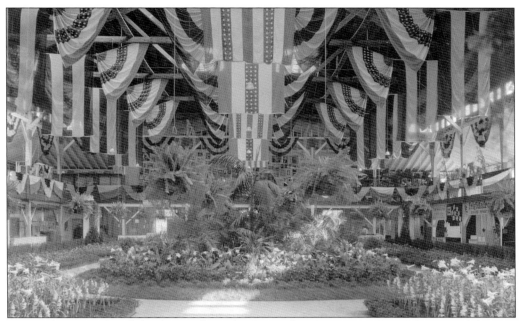

Bester Florist produced this horticulture display at the Hagerstown Fair. The annual fair was famous throughout the eastern United States, and the four major railroads that used Hagerstown as a hub brought thousands to the fair. Trolley cars were borrowed from neighboring Frederick to accommodate the influx of people. (Courtesy Washington County Historical Society.)

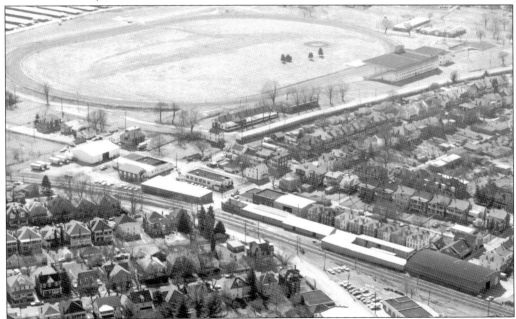

This aerial view shows the wide expanse of the racetrack at the fairgrounds. The grandstand is the large structure on the right. (Courtesy Western Maryland Room, Washington County Free Library.)

Pictured here is Main Street at the Hagerstown Fairgrounds. Washington County groups as well as associations from neighboring counties in Maryland, Pennsylvania, Virginia, and West Virginia participated in the Great Hagerstown Fair each year. The poultry exhibit at the fair became the largest in the nation and, at the turn of the 20th century, had over 5,000 birds on exhibit. (Courtesy Western Maryland Room, Washington County Free Library.)

Huge crowds packed the grandstand at the fairgrounds for this fireworks display on July 4, 1955. (Courtesy Western Maryland Room, Washington County Free Library.)

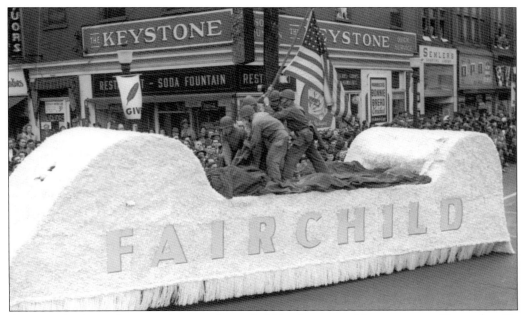

A veteran's victory homecoming parade was held in downtown Hagerstown on November 11, 1946. The Fairchild float shown here was a depiction of the historic raising of the U.S. flag at Iwo Jima. Note the old Keystone Restaurant and Soda Fountain on the corner of West Washington and South Potomac Streets. People's Drug would later occupy this corner of the square. (Courtesy Washington County Historical Society.)

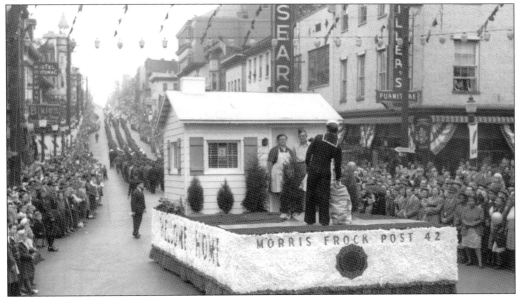

Another float proceeds up North Potomac Street during the November 11, 1946 World War II veteran's parade. The Morris Frock Post 42 float was a simple but moving depiction of a sailor coming home with his parents waiting to welcome him. Sears and Miller's Furniture can be seen on the right, and Bikle's, Hoffman's, and the Potomac Hotel are on the left. (Courtesy Washington County Historical Society.)

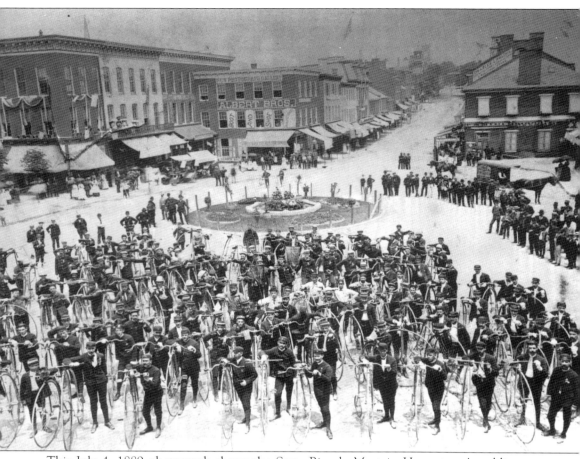

This July 4, 1889 photograph shows the State Bicycle Meet in Hagerstown's public square. Bicycling has a long tradition in Hagerstown, and the Hagerstown Bicycle Club was started in 1884. There were even large indoor gyms where enthusiastic cyclists could ride during inclement weather. The tradition continues today as, in recent years, a leg of the famed Tour du Pont race has come right through downtown Hagerstown. Note the wide-open space of the square with the planted centerpiece. (Courtesy Washington County Historical Society.)

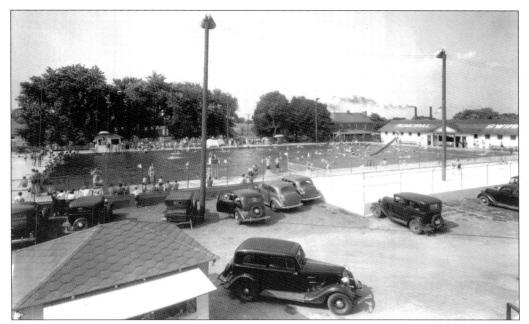

Here is the Hagerstown Municipal Swimming Pool in 1938. During the war years, lifeguard duties began to be taken over by young women, and the pool was a popular spot on hot summer days. Still located on Frederick Street, the pool is now known as the C.M. Potterfield Pool. (Courtesy Washington County Historical Society.)

Professional baseball first came to Hagerstown in 1915 when the Hubs entered the Blue Ridge League. They won their first pennant in 1917. The Owls, shown above, played at Municipal Stadium from 1941 to 1950. The team became the Braves from 1950 to 1953 and then the Packets. Today, baseball is still popular in Hagerstown and residents cheer for the Hagerstown Suns. (Courtesy Washington County Historical Society.)

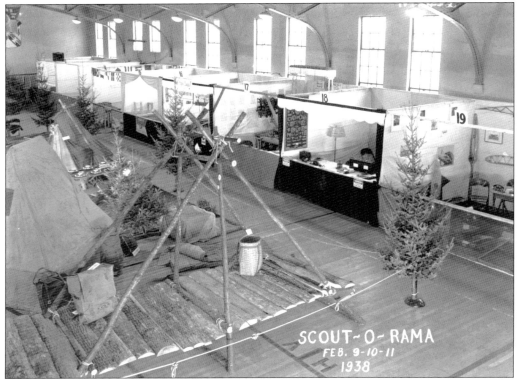

Scouting has long played a role in Hagerstown, and the first Boy Scout units were present in the area as early as 1910. This February 1938 image shows exhibits from a Scout-O-Rama event held inside a local gymnasium. (Courtesy Washington County Historical Society.)

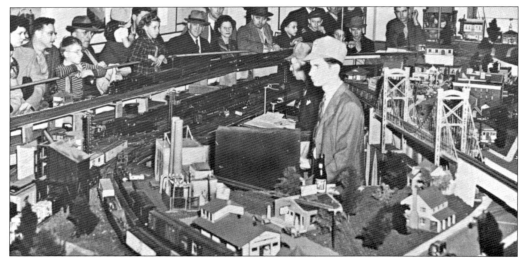

With Hagerstown's position as a natural hub for railroad activity, interest in model railroading has long been a popular pastime in Hagerstown. Here, the Hagerstown Model Railroad Club hold their Eighth Annual Model Railroad Show in November/December 1945. Note the elaborate layout and realistic bridges and buildings. (Courtesy Maryland Cracker Barrel.)

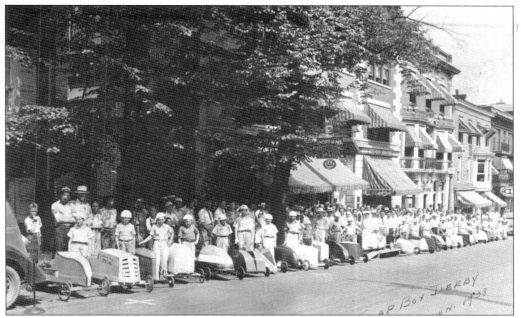

In 1938 Hagerstown held its first Soapbox Derby. Here, the contestants are lined up on West Washington Street in front of Hoffman-Chevrolet, the derby's sponsor. At that time, the car dealership was located in the Wareham Building. Still in business, Hoffman's is now located on the corner of Edgewood Drive and Howell Road. (Courtesy *Maryland Cracker Barrel.*)

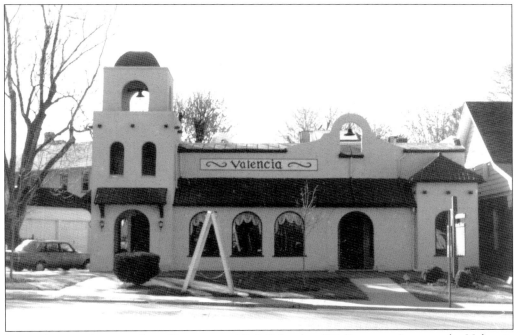

Located across the street from Hagerstown High School at 121 Potomac Avenue, the Valencia Restaurant was a famed gathering place for the school crowd after class. Today, the distinctive building houses Richard's World of Travel. (Courtesy Washington County Historical Society.)

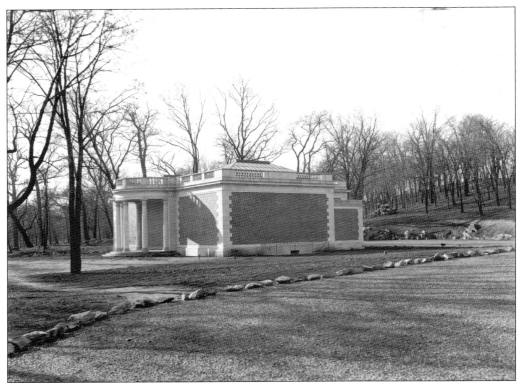

The Washington County Museum of Fine Arts was incorporated in 1929 and was constructed as a centerpiece of Hagerstown's City Park. The building was expanded in 1948 and 1994 to enhance its ability to serve the artistic needs of the four-state area (Maryland, Virginia, West Virginia, and Pennsylvania). (Courtesy Western Maryland Room, Washington County Free Library.)

Here is just one of the many tranquil sites to be found in Hagerstown's City Park. Ducks, geese, squirrels, fish, and swans all make their homes in the park. (Courtesy Western Maryland Room, Washington County Free Library.)

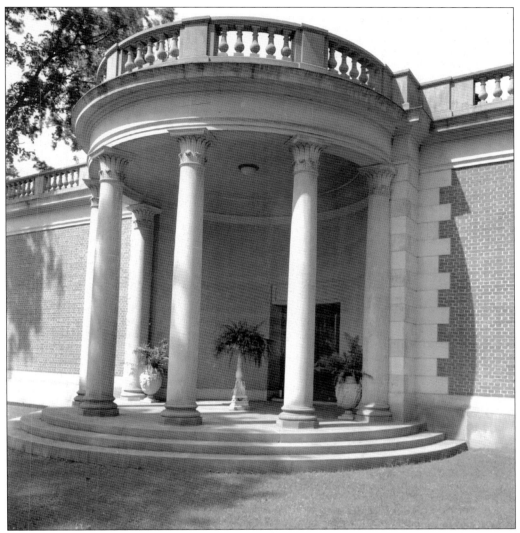

The Museum of Fine Arts has a noteworthy collection of American paintings, prints, drawings, and sculpture from the 18th century to the present day. The works include a wide range, from early colonial portraiture to the works of Maryland artists and artists of the famed Hudson River School. Works by Courbet, Rodin, and other old masters are part of the collection, as well as Oriental and decorative arts. (Courtesy Western Maryland Room, Washington County Free Library.)

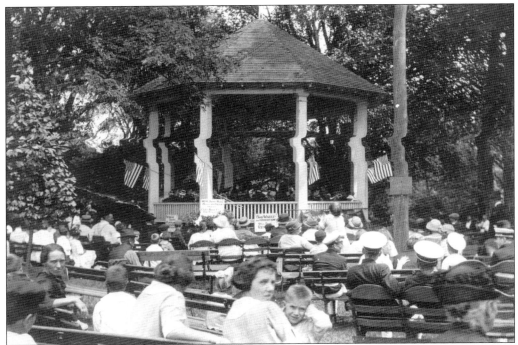

The bandstand in Hagerstown's City Park is seen here during a Labor Day concert in 1922. After many years, this bandshell was moved and now sits in Wheaton Park. (Courtesy Western Maryland Room, Washington County Free Library.)

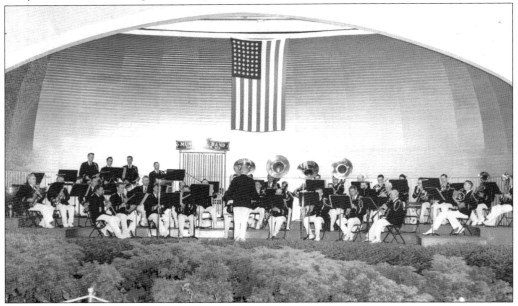

The Hagerstown Municipal Band performs in the bandshell at City Park in 1953. Concerts in the park have had a long tradition in Hagerstown and even today Sunday evenings during the warm summer months find large turnouts for the band's free concerts. (Courtesy Washington County Historical Society.)

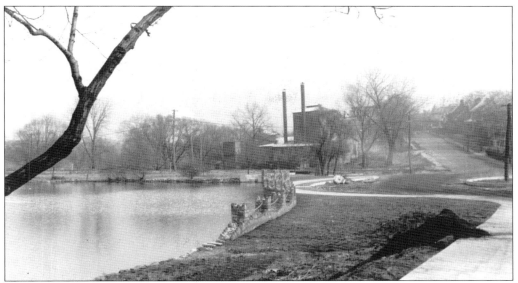

This photograph from the early 1900s shows the Bester Ice Plant. Prospect Street runs downhill to the right of the plant ending up in Millstone (also known as Park) Circle. The lake and a portion of the decorative wall at City Park take up the left side of the image. In the center of the picture, just to the right of the wall around the lake, it appears that one of the millstones embedded in the sidewalks around Park Circle is waiting to be set in place. (Courtesy Washington County Historical Society.)

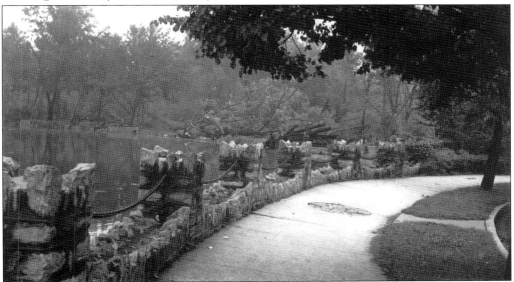

Hagerstown City Park is pictured here after a major storm; many trees and limbs are down in the background. Also visible is one of the eleven millstones embedded in the sidewalks around the Park Circle area. Millstones were once used to grind grain in Washington County mills but were no longer in use in 1922 when the plans for Millstone Circle were created. The stones were embedded in the sidewalks as a means of preserving some of the county's rich heritage. Each has a bronze square in the center with the name of the mill the stone came from and the date the mill was built. (Courtesy Washington County Historical Society.)

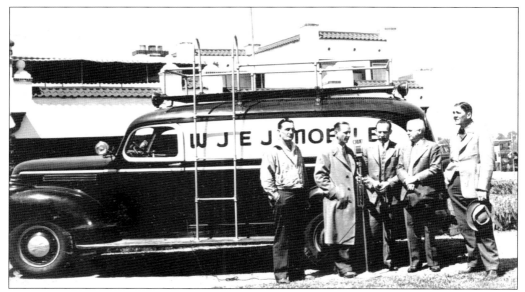

The WJEJ mobile unit was often out and about town. As radio technology advanced and allowed transmissions outside the station, new programs thrived. One of the most popular programs of the 1930s was WJEJ's "Man in the Street" in which local citizens were interviewed about community affairs. This photograph was taken prior to World War II at Charles Town, West Virginia. (Courtesy Washington County Historical Society.)

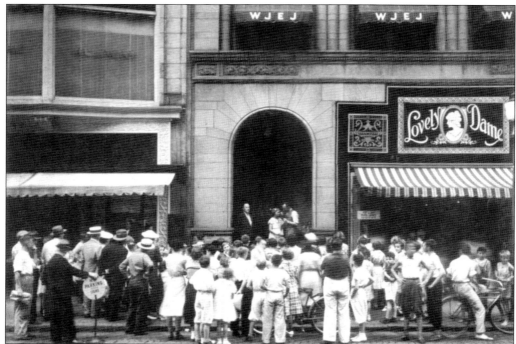

A 1930s photo of the "Man in the Street" broadcast is in progress and a young lady is being interviewed in front of an audience. The WJEJ studio was located above the Lovely Dame restaurant on West Washington Street at this time. (Courtesy Maryland Cracker Barrel.)

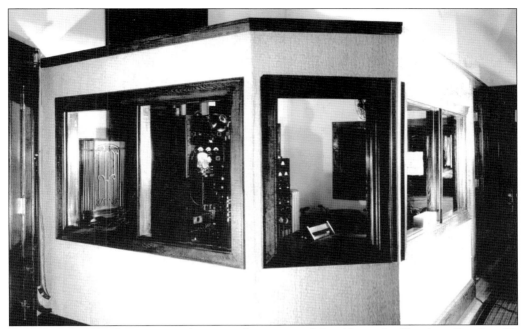

WJEJ broadcast its first program from a studio on top of the Alexander Hotel on October 29, 1932. The station operated from 8 a.m. to 4 p.m. daily. After war was declared in 1941, radio stations were prime targets and transmitter operators were issued firearms. Here we see the broadcasting booth inside the radio station. (Courtesy Washington County Historical Society.)

Early radio was all done in front of a live audience, and this room is set up to hold the public for the next broadcast. (Courtesy Washington County Historical Society.)

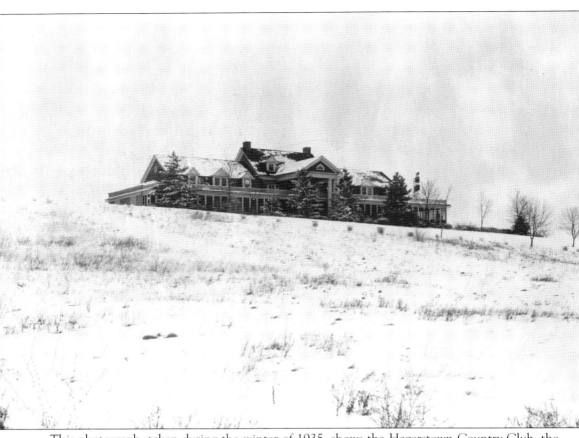

This photograph, taken during the winter of 1935, shows the Hagerstown Country Club, the first nightclub in the area after the end of Prohibition. The club featured golf, tennis, billiards, and bowling, as well as a library, dance hall, and dining room. Now, this building off Northern Avenue is the site of the American Legion Morris Frock Post No. 42. (Courtesy Western Maryland Room, Washington County Free Library.)